KU-601-460

Donated to

**Visual Art Degree
Sherkin Island**

B 1151 8261

LIBRARY
D.I.T. MOUNTJOY SQ.

Anne van Cutsem

A World of Rings

Africa, Asia, America

Photographs by
Mauro Magliani

English translation by Susan Wise

SKIRA

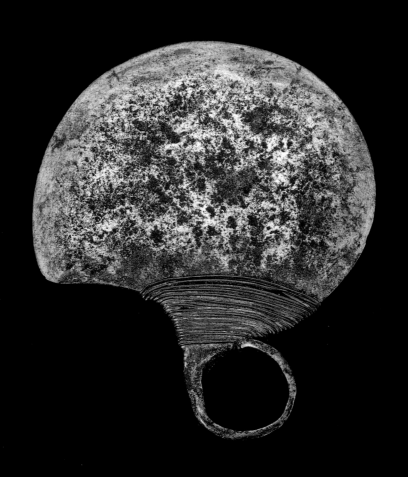

Africa

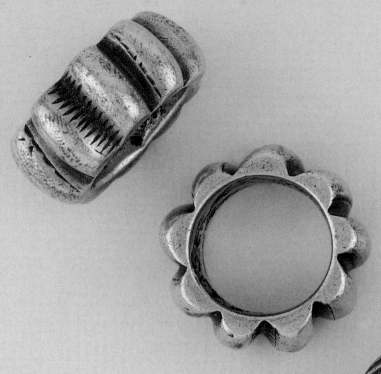
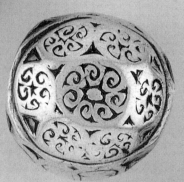
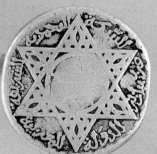
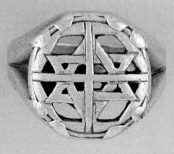

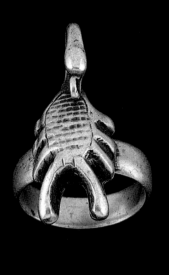
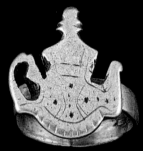
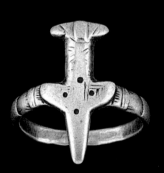
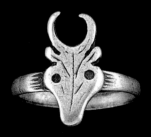

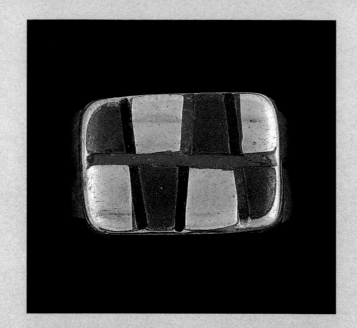

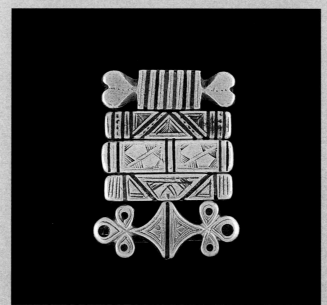

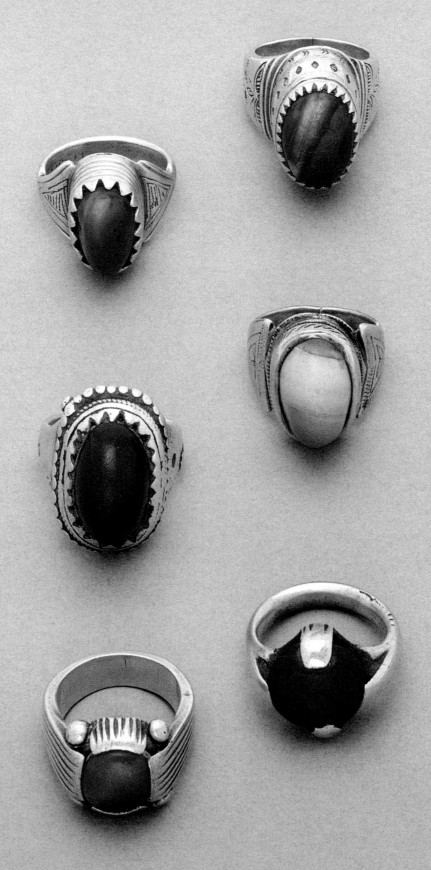

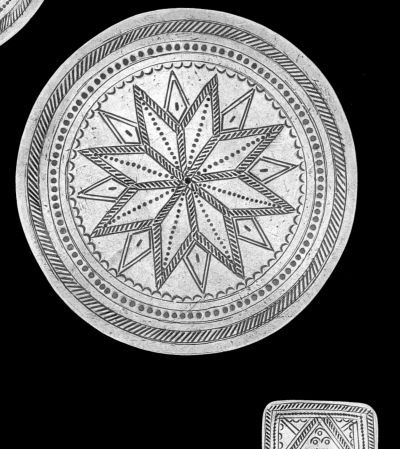

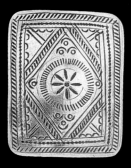
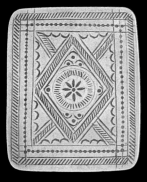

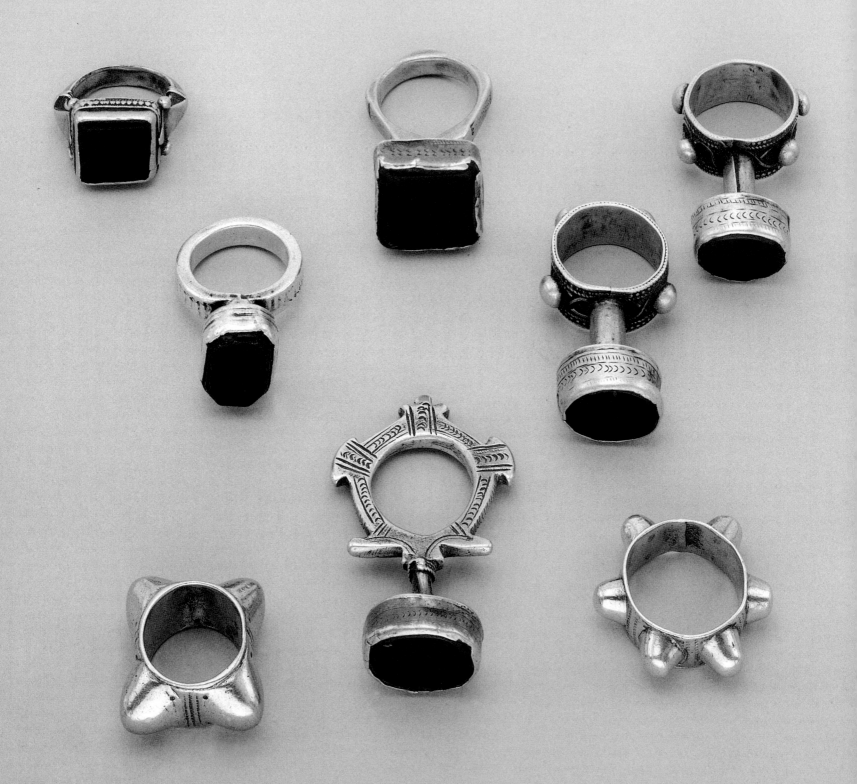

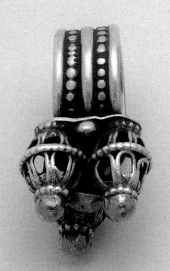
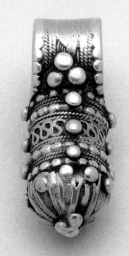
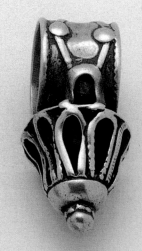
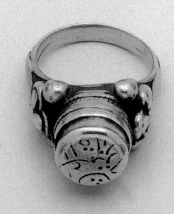
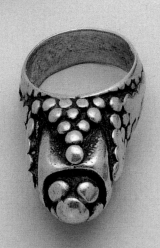
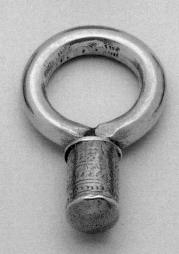
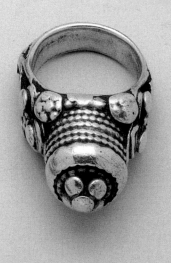

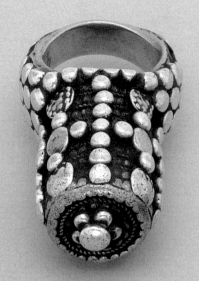
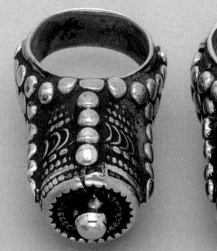
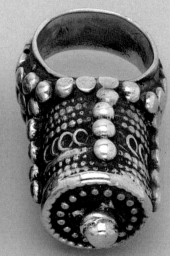
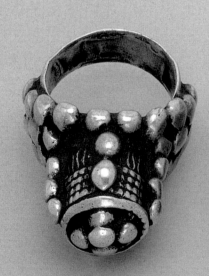
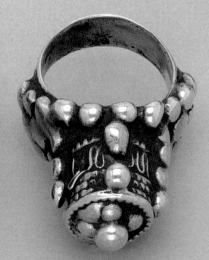

32

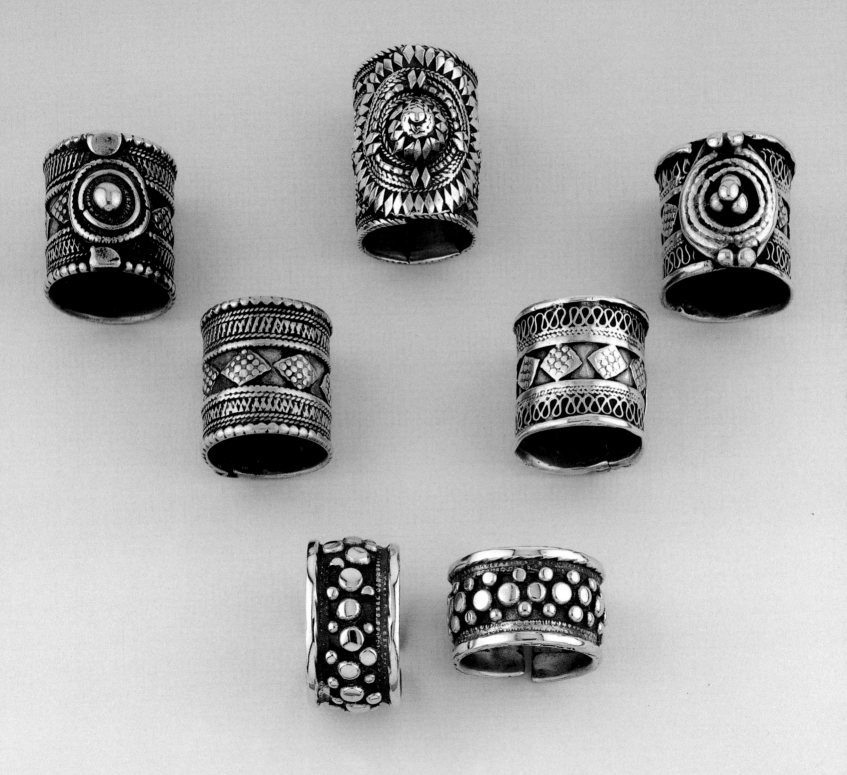

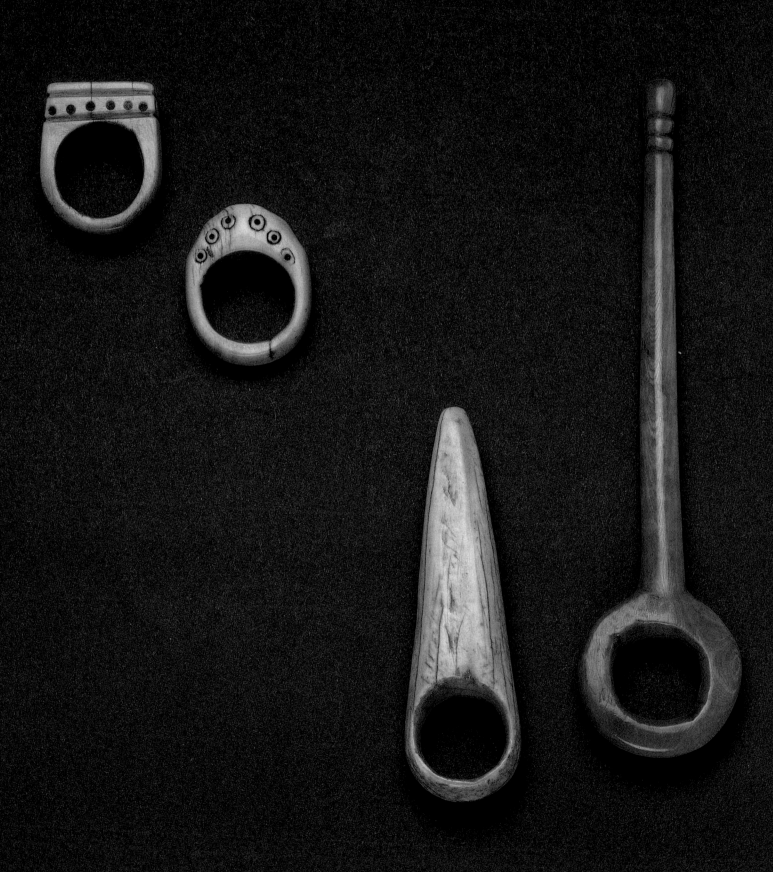

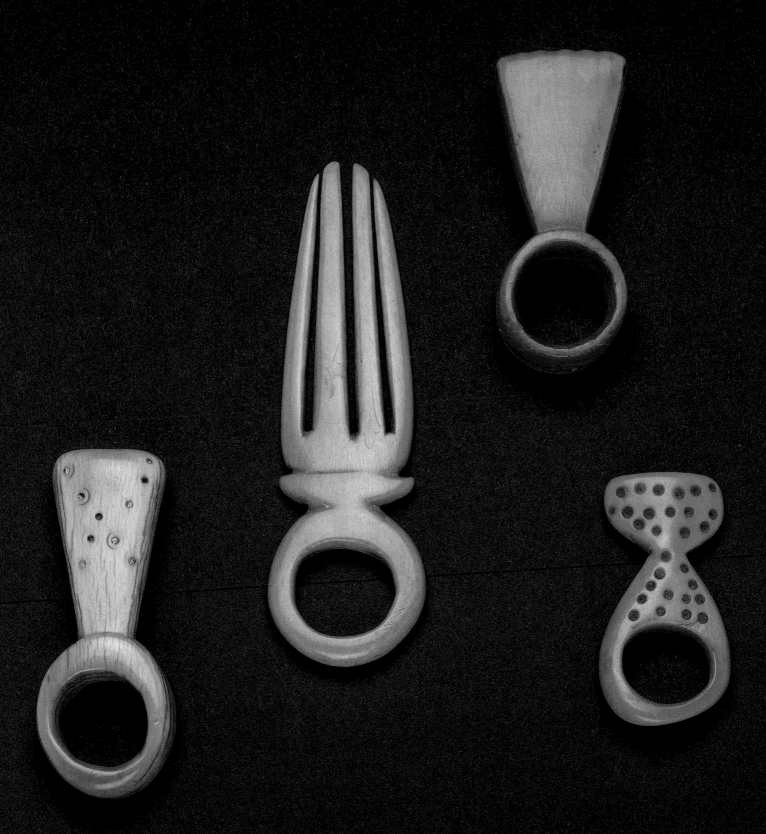

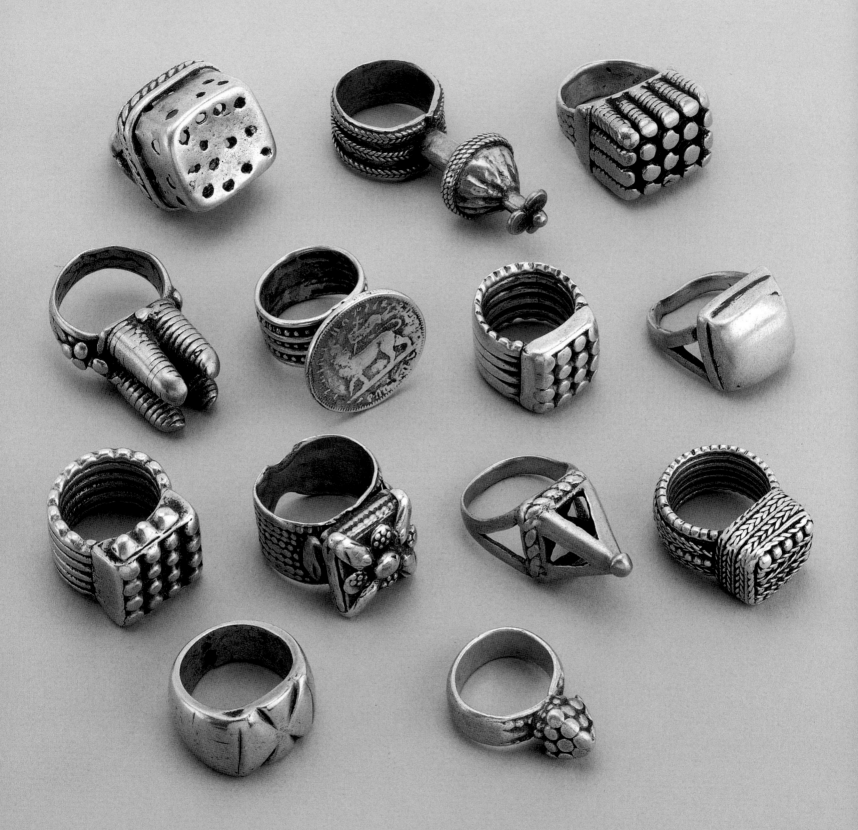

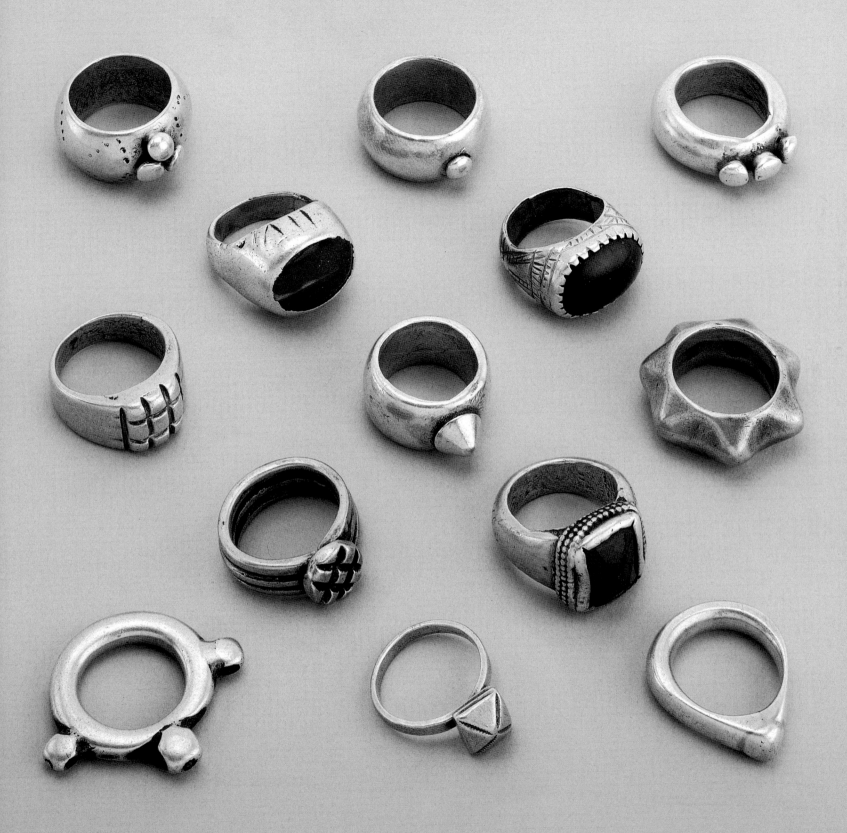

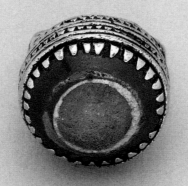

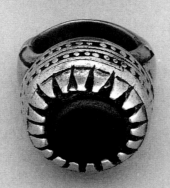

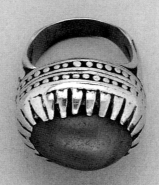

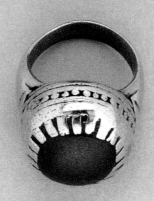

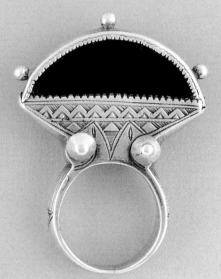

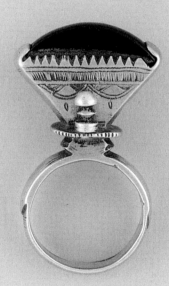

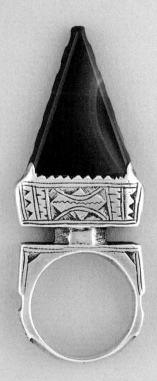

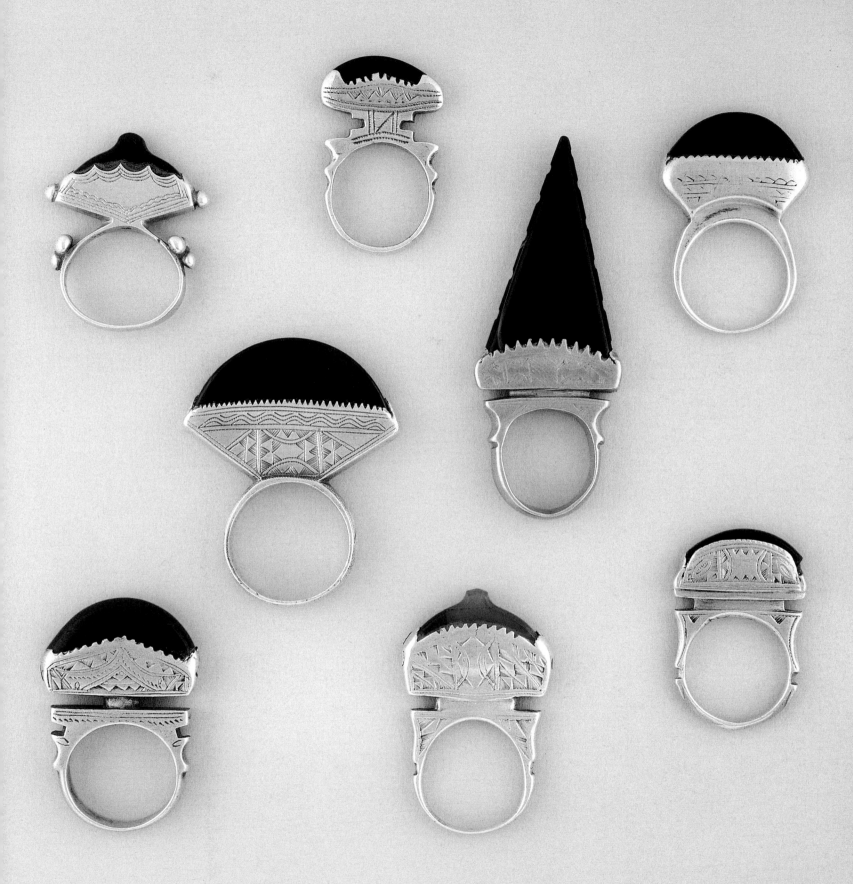

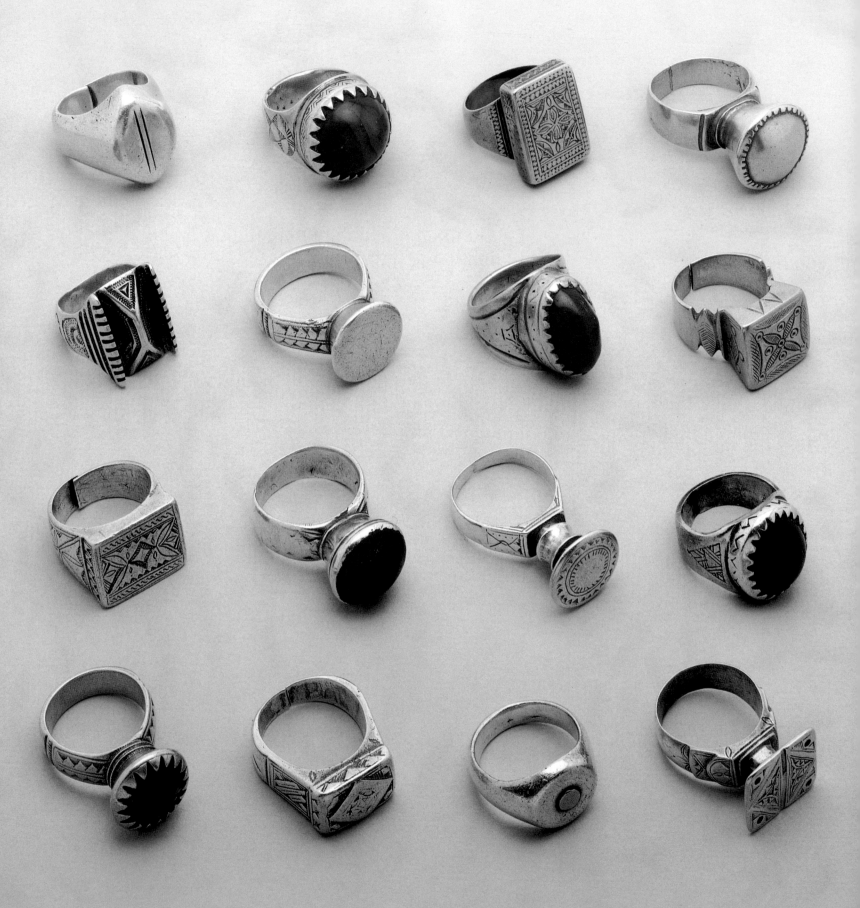

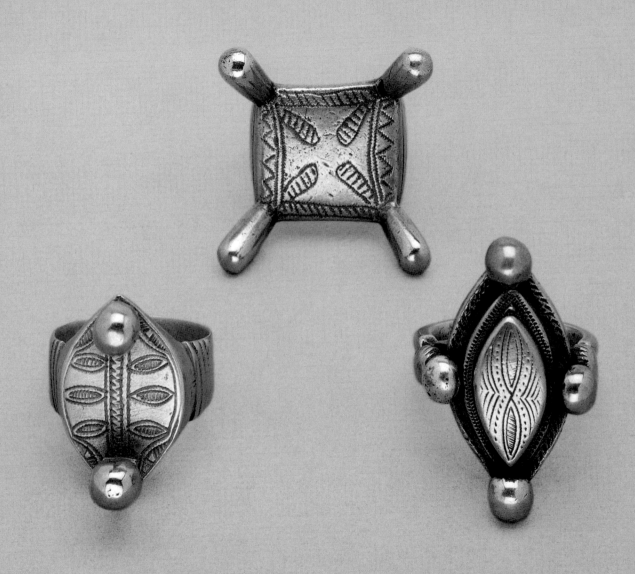

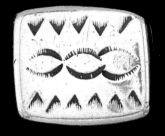
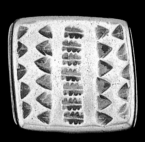
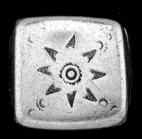

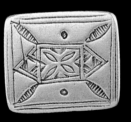
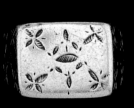

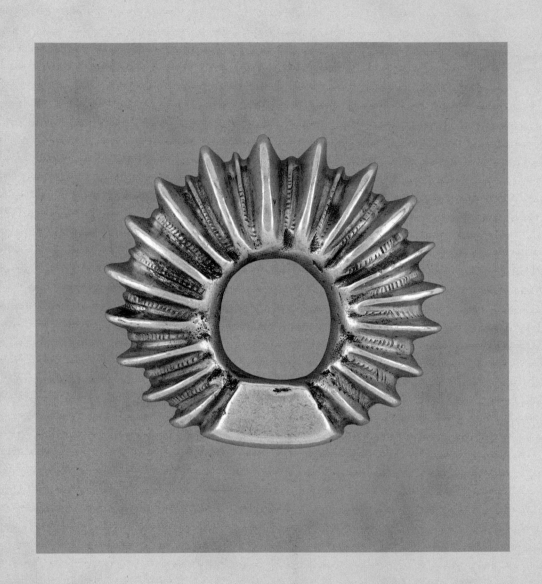

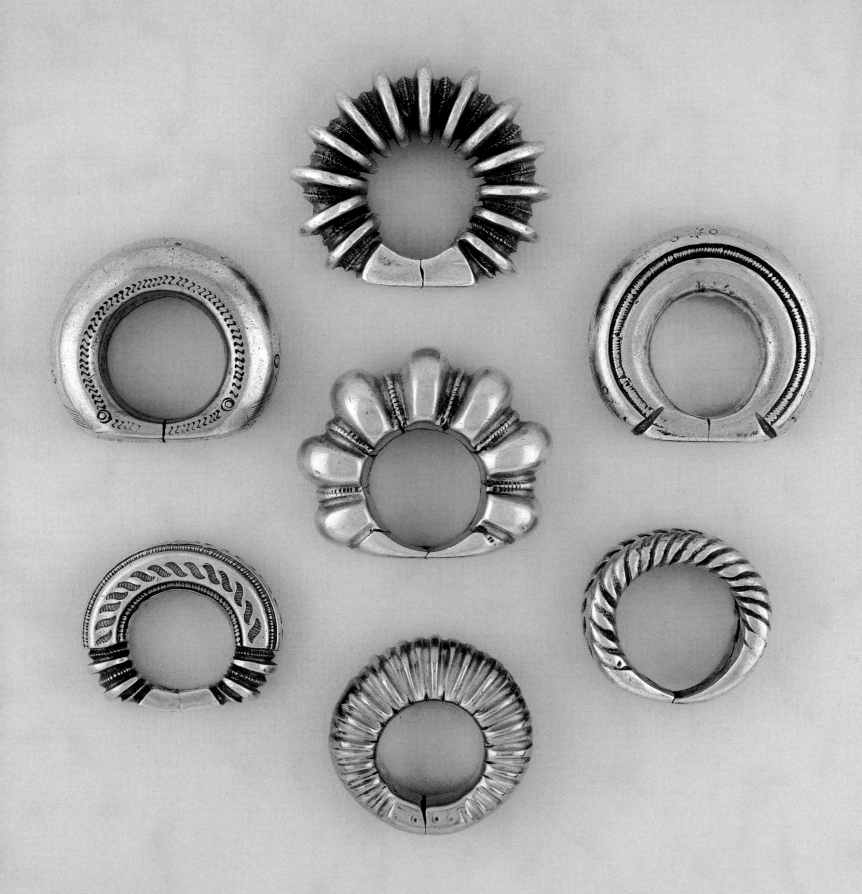

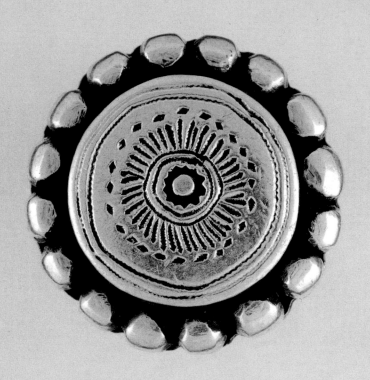

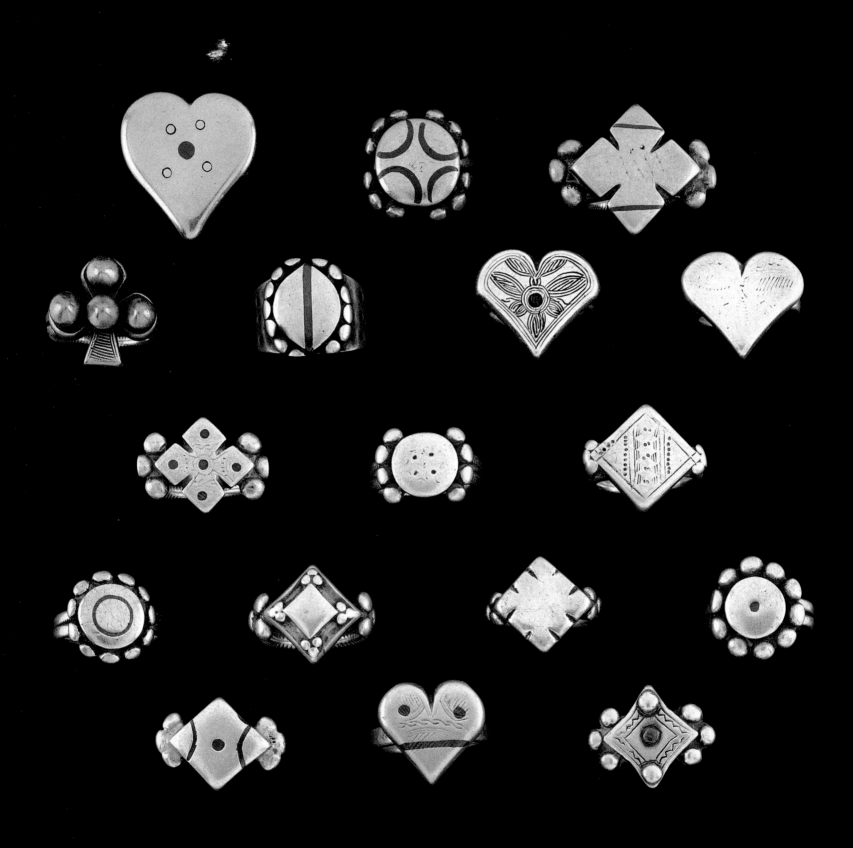

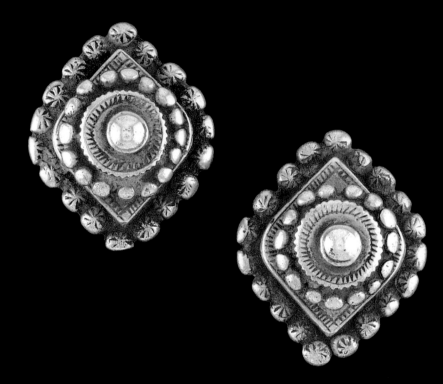

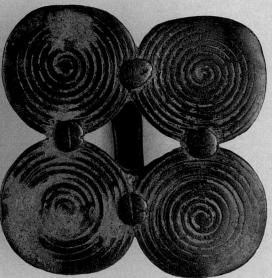

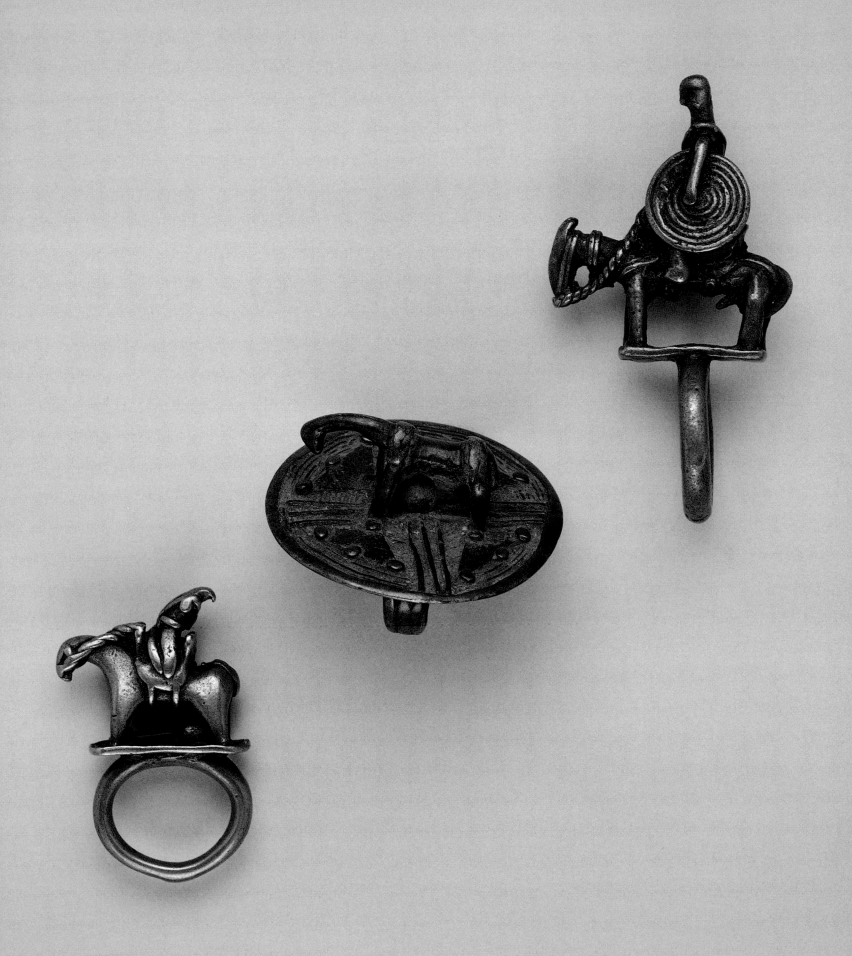

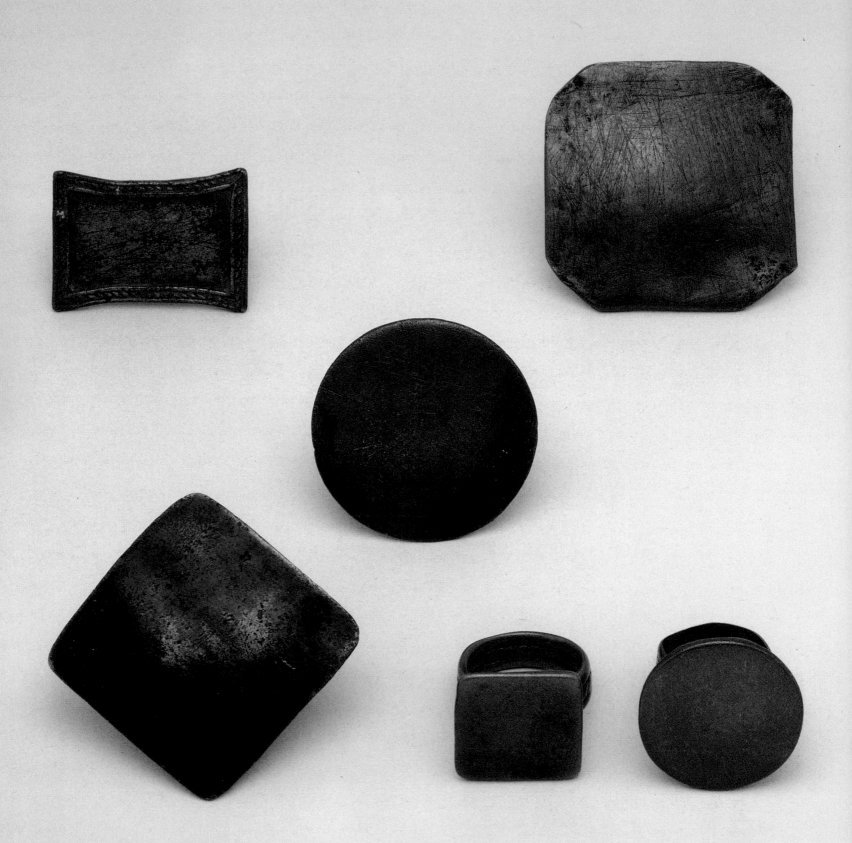

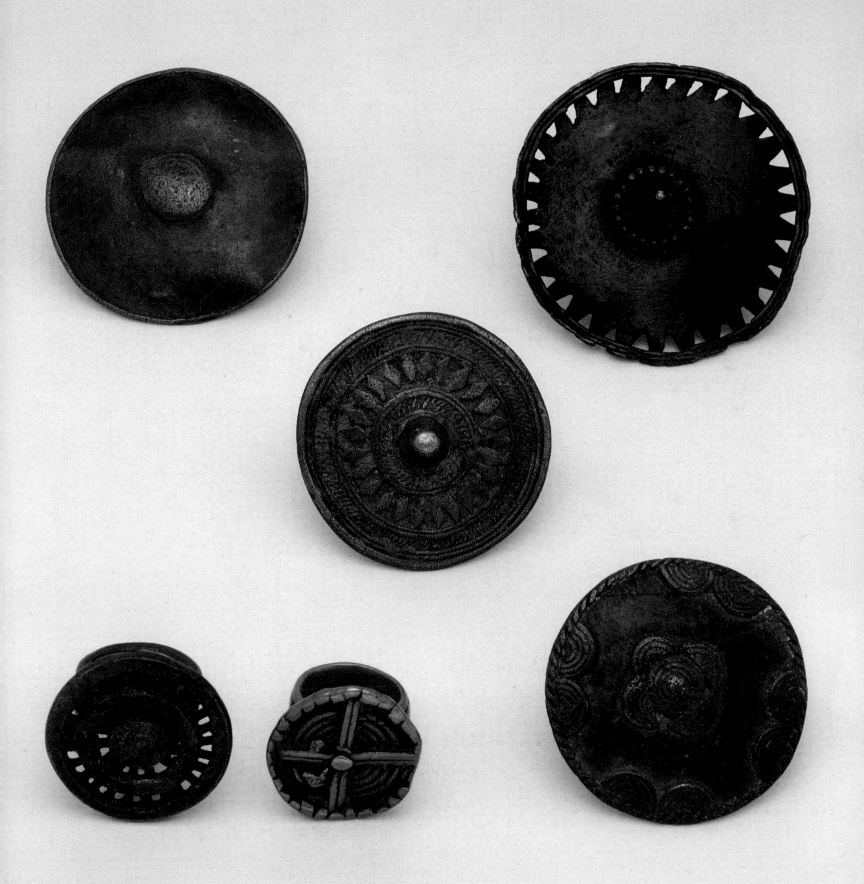

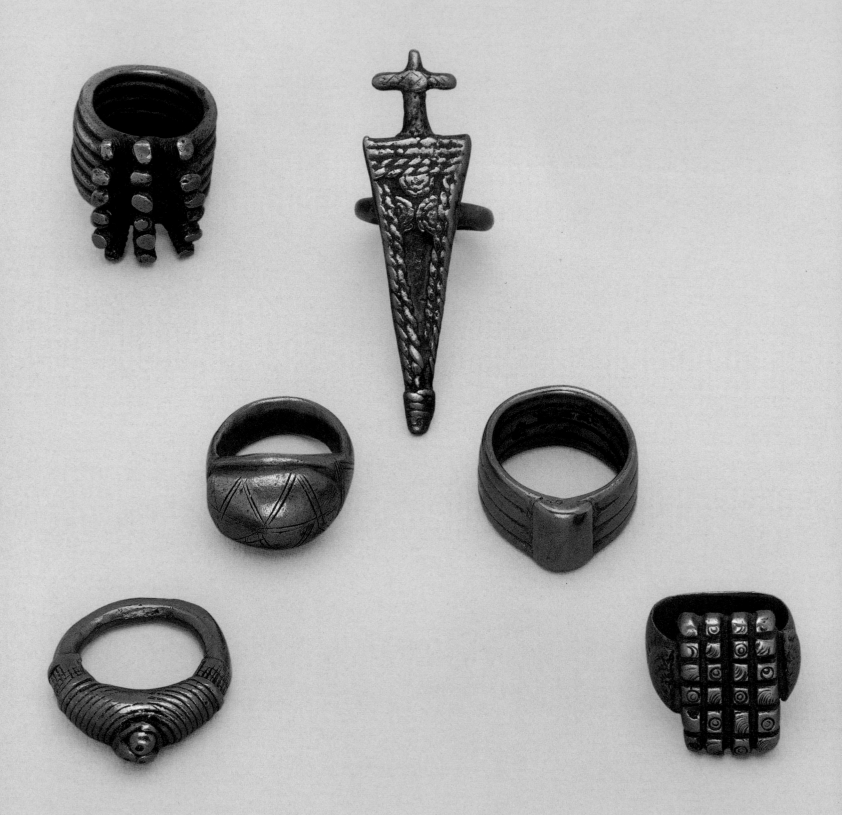

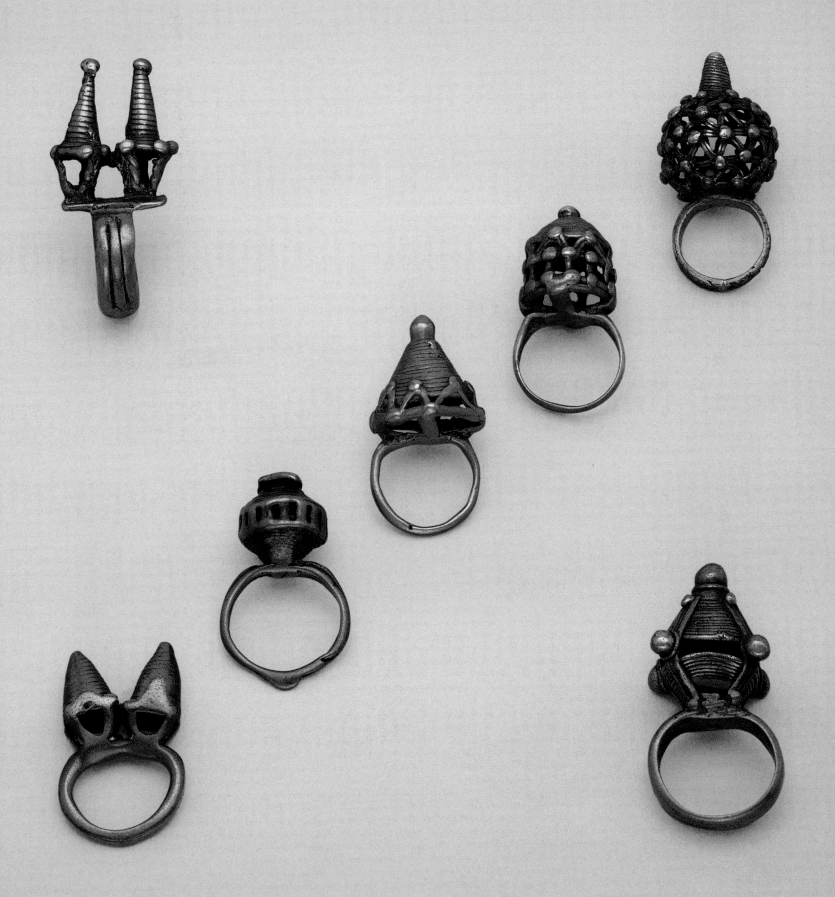

65

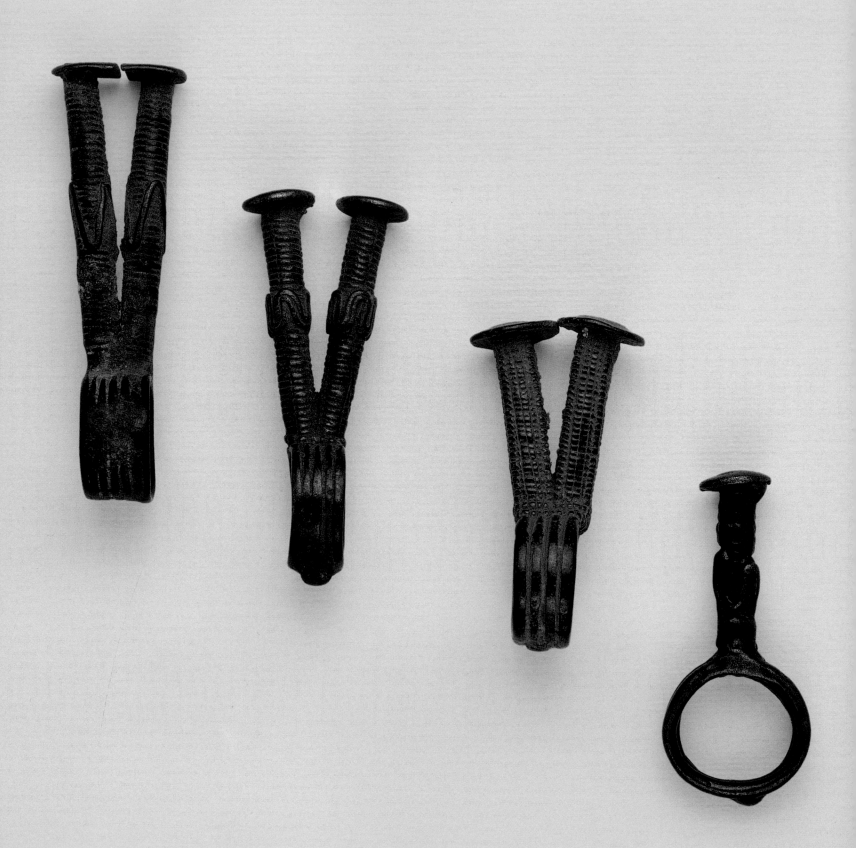

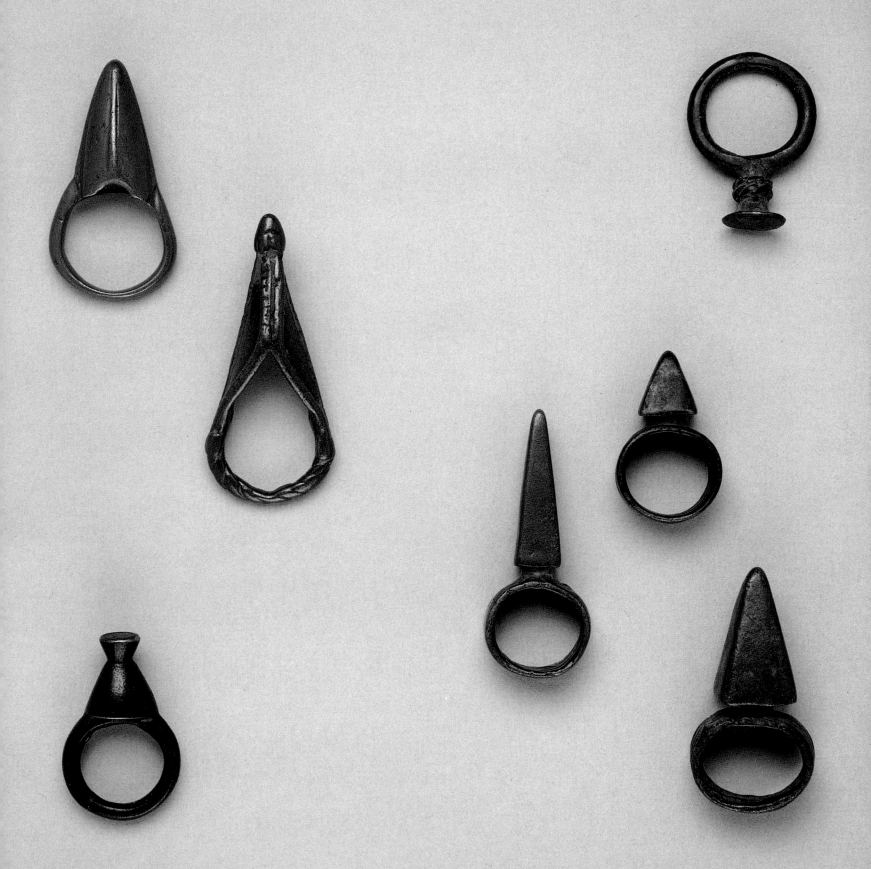

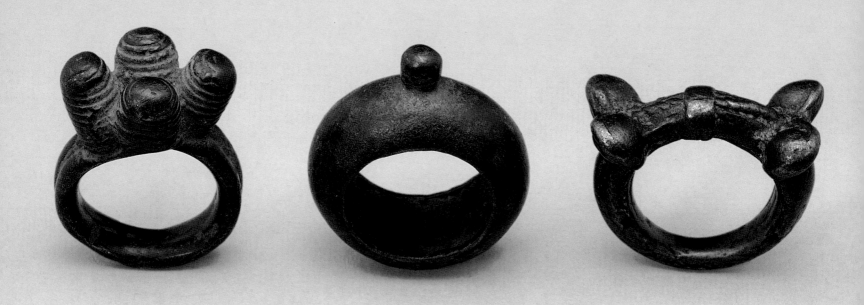

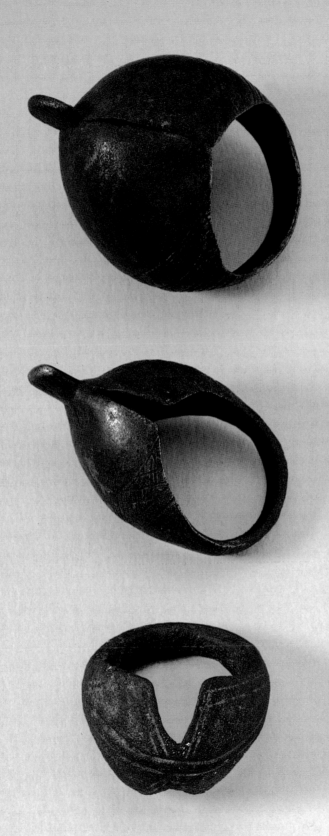

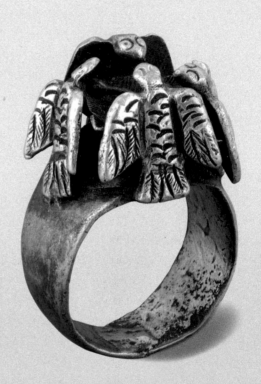

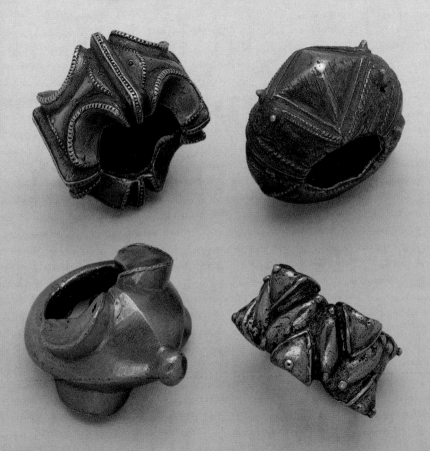

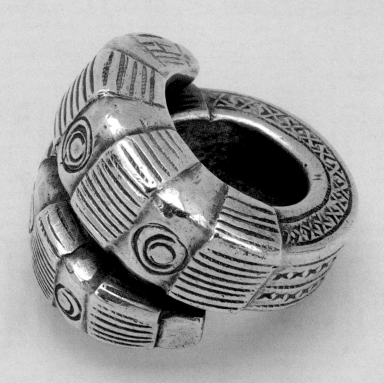

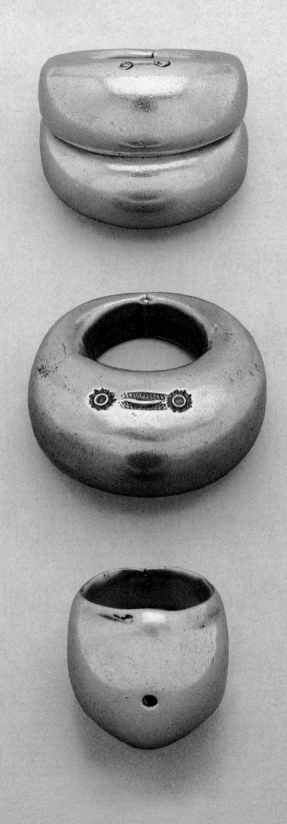

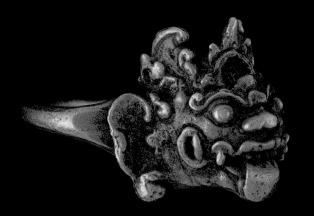

Asia

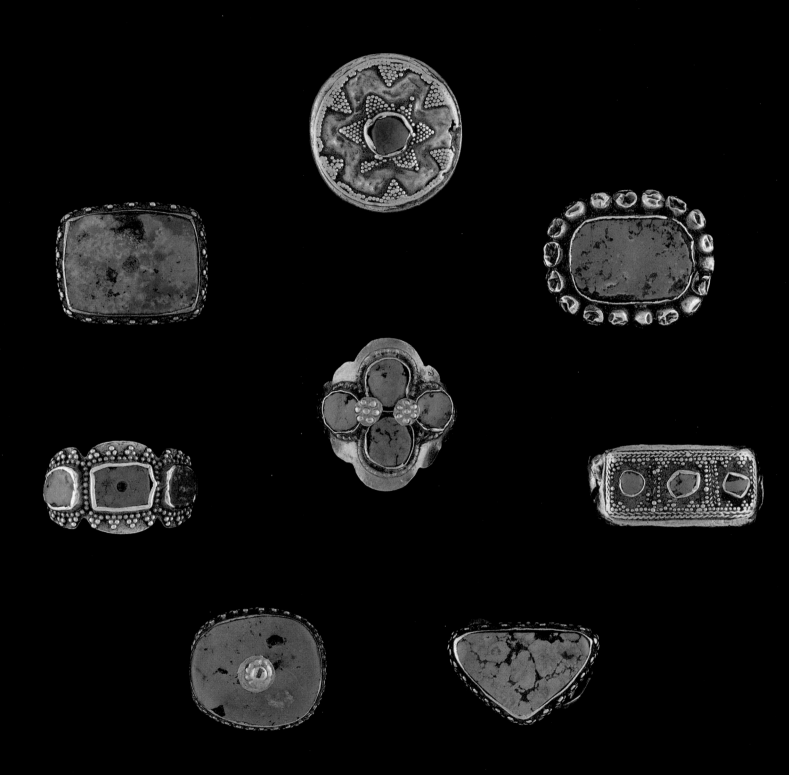

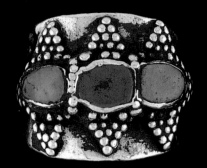
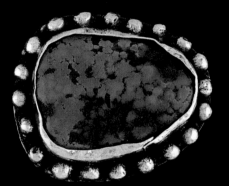
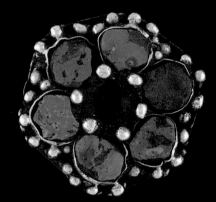
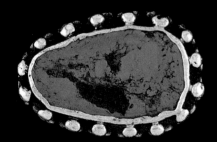

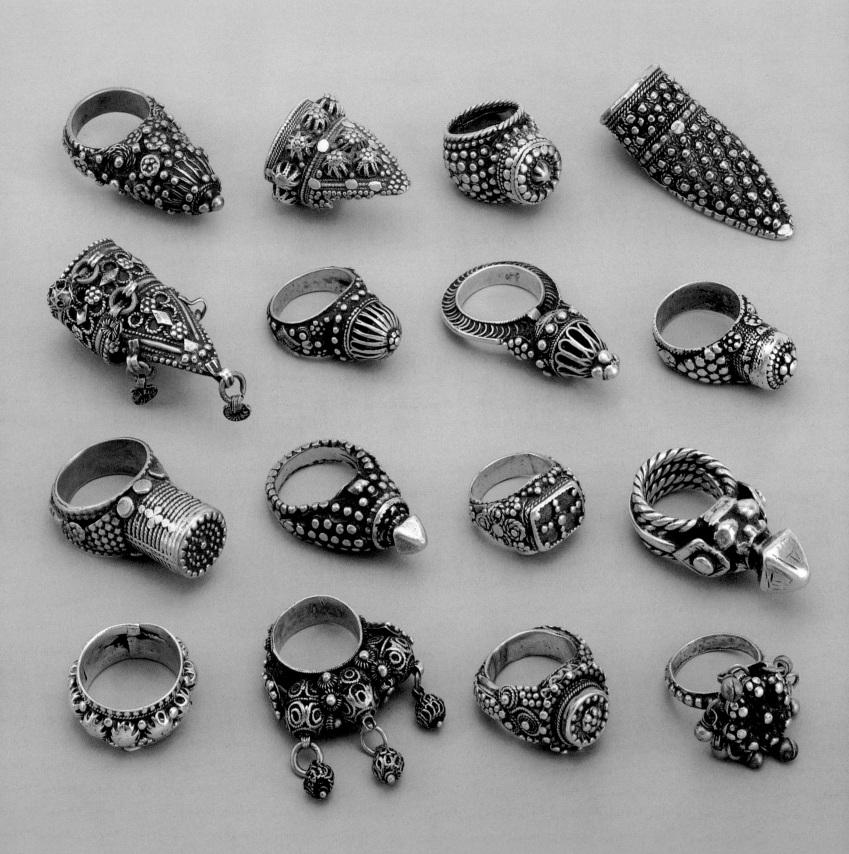

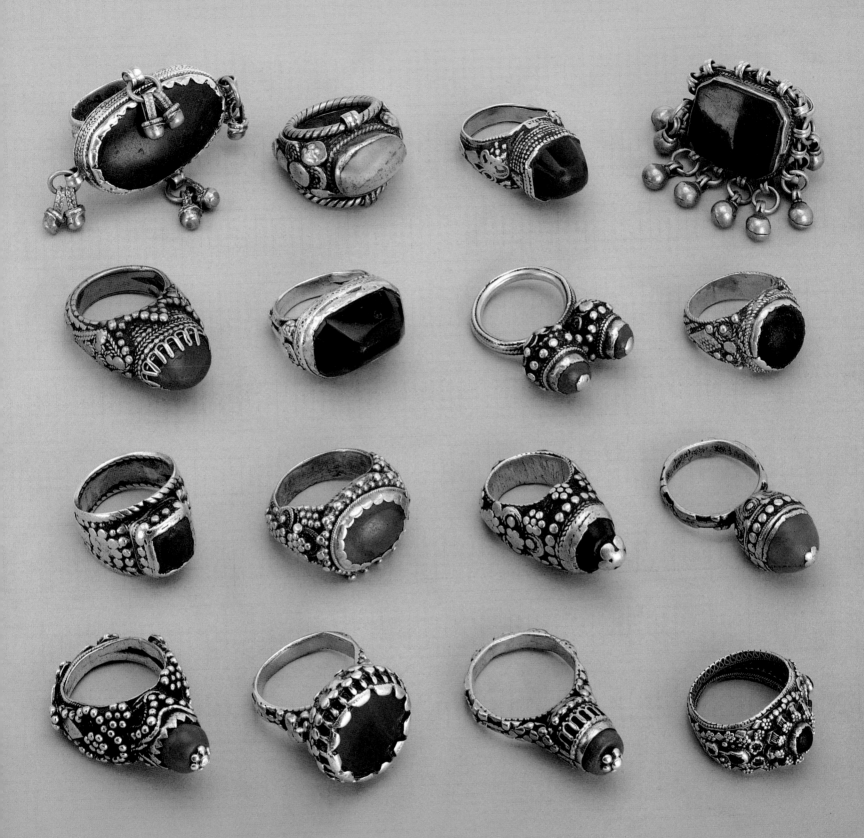

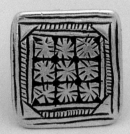
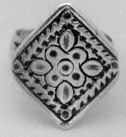
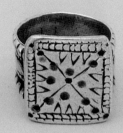
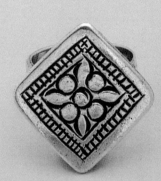
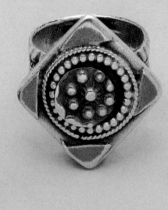
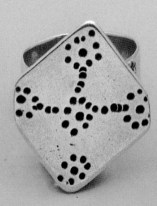
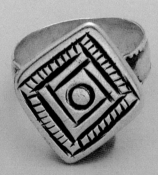

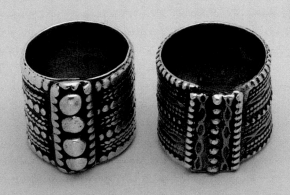
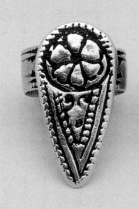
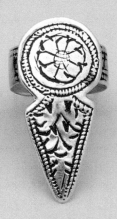
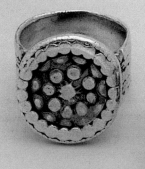

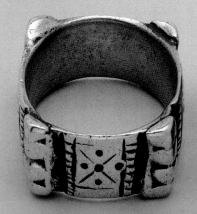
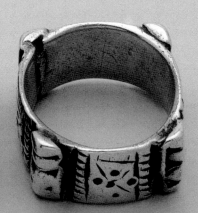

D.I.T.
LIBRARY
MOUNTJOY SQ.

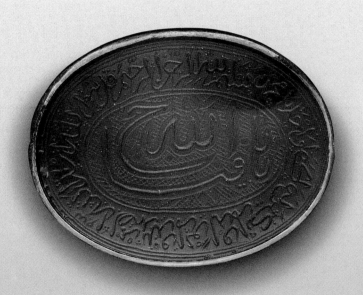

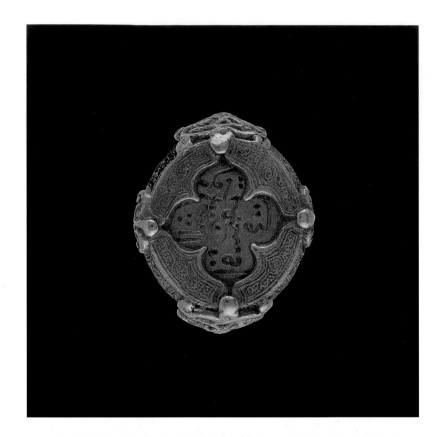

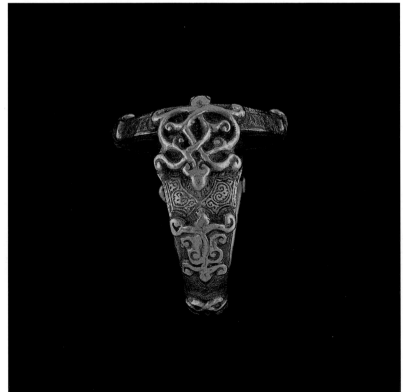

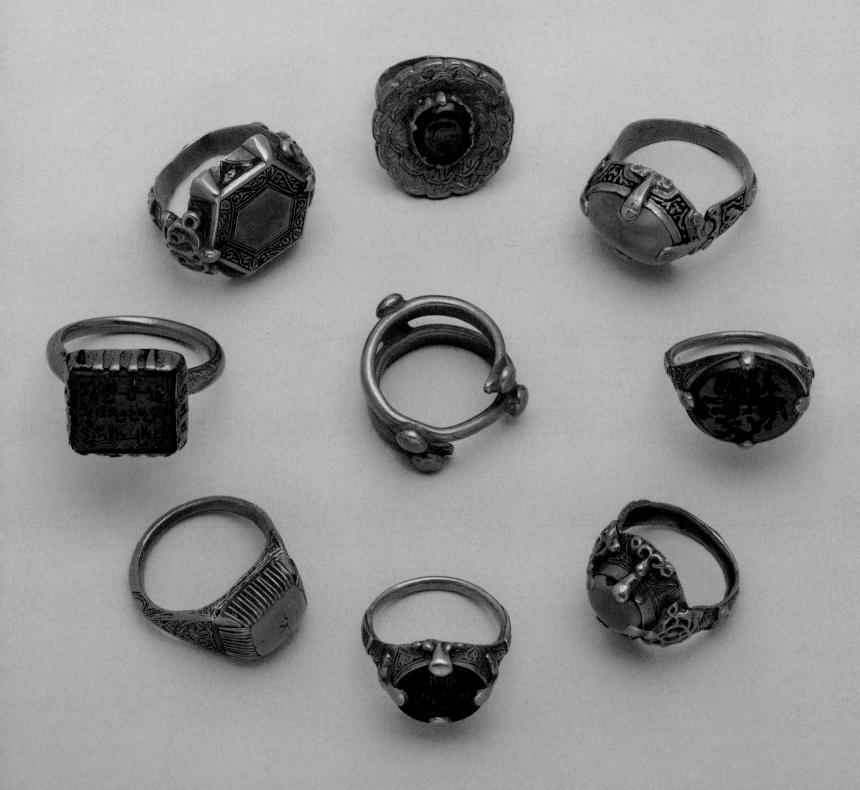

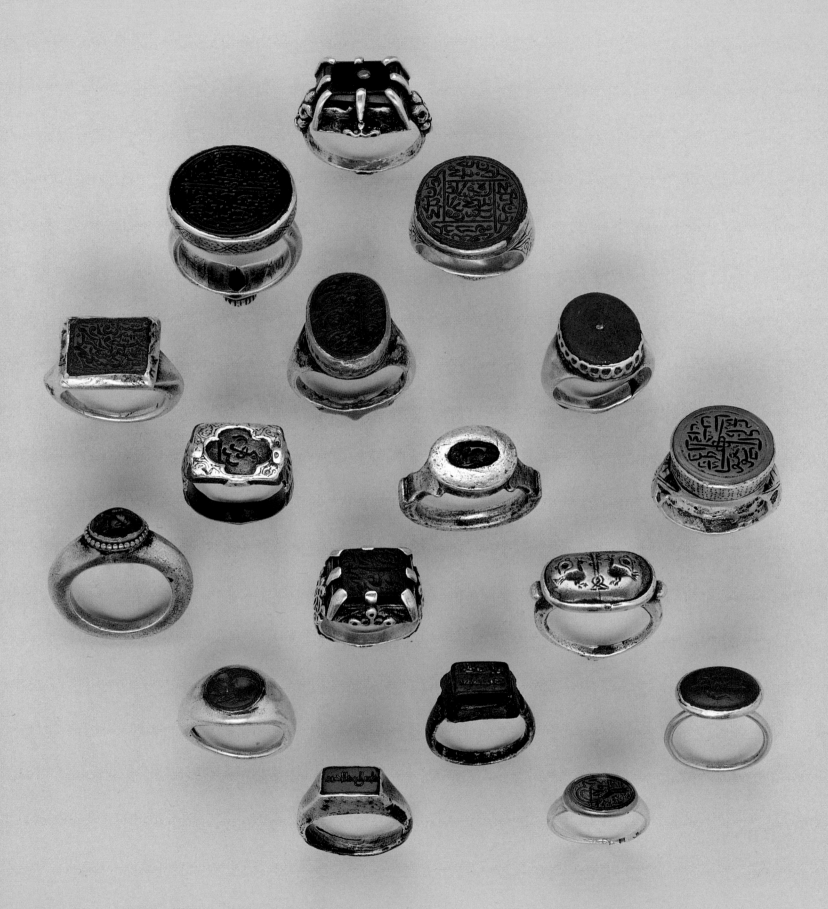

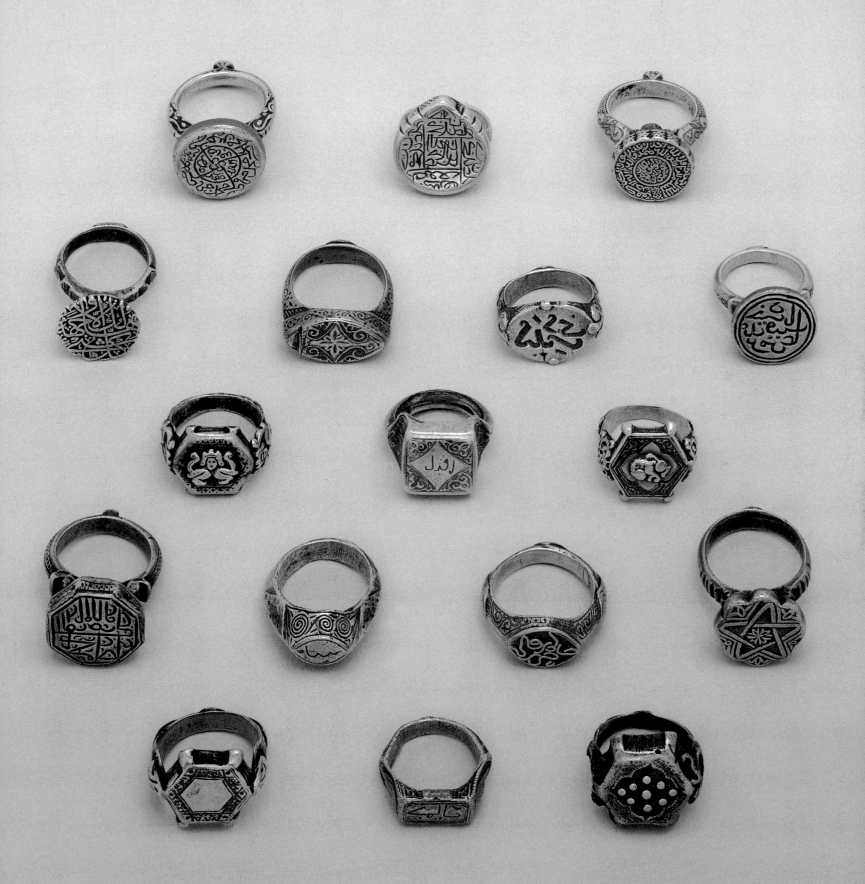

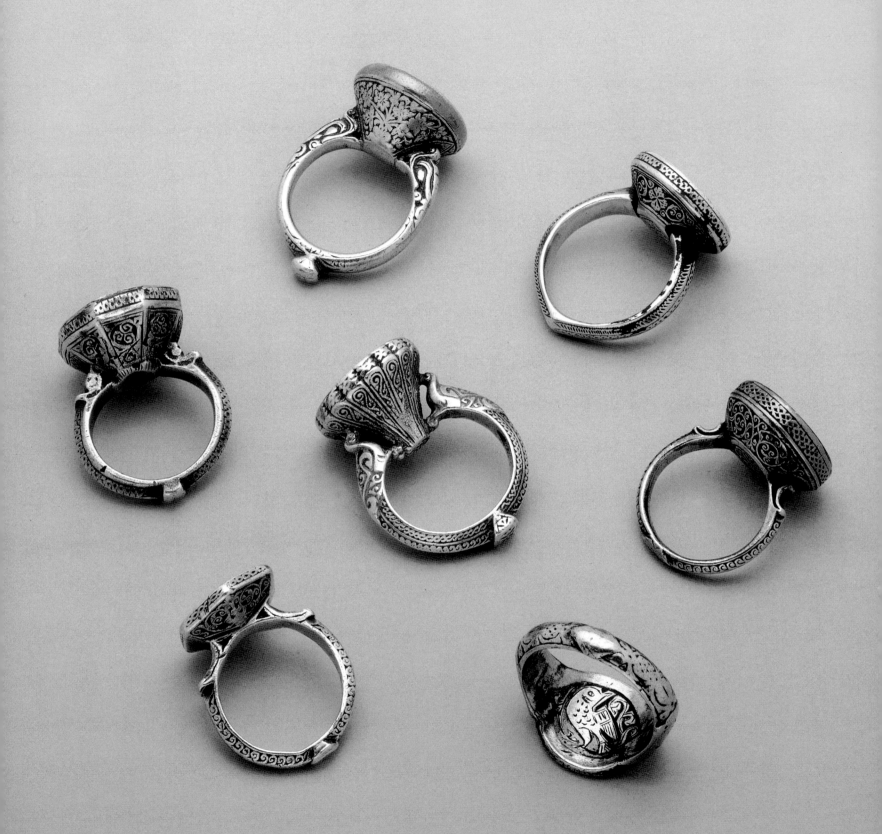

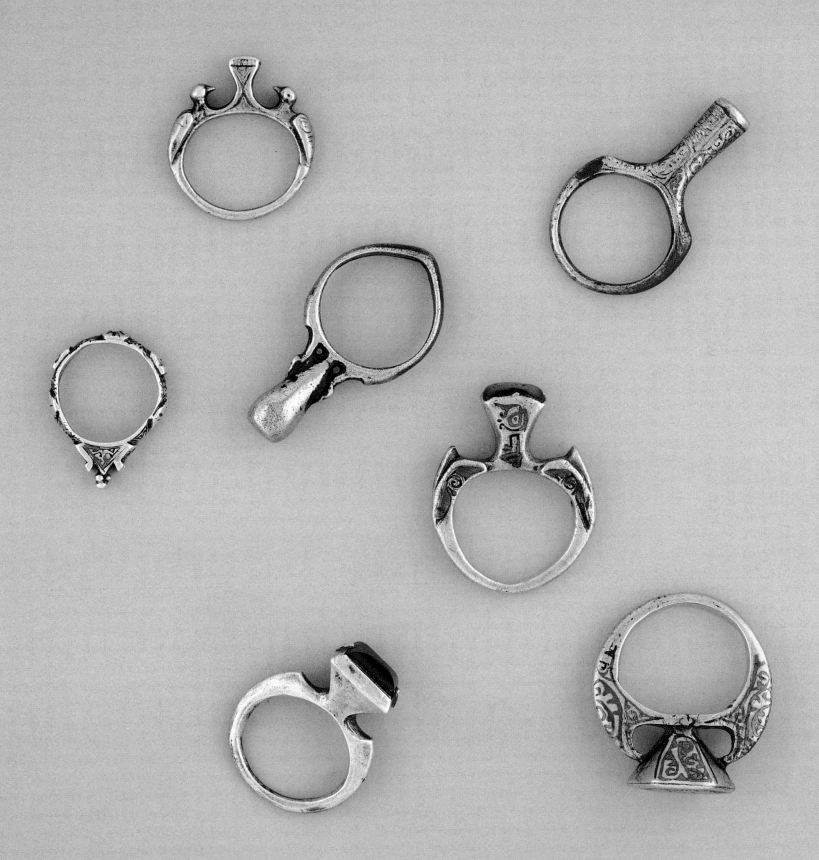

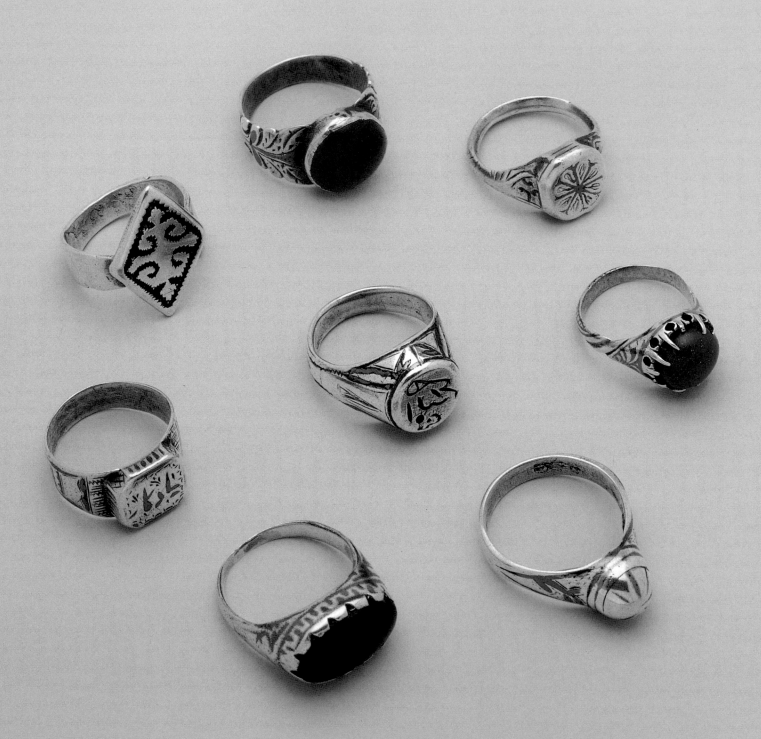

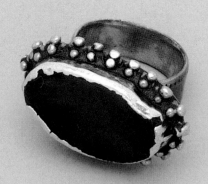

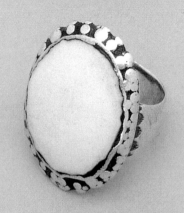

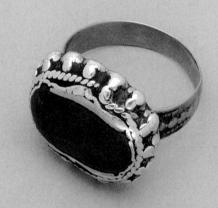

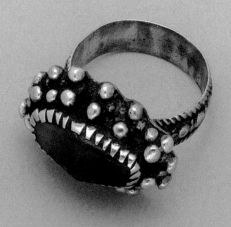

111

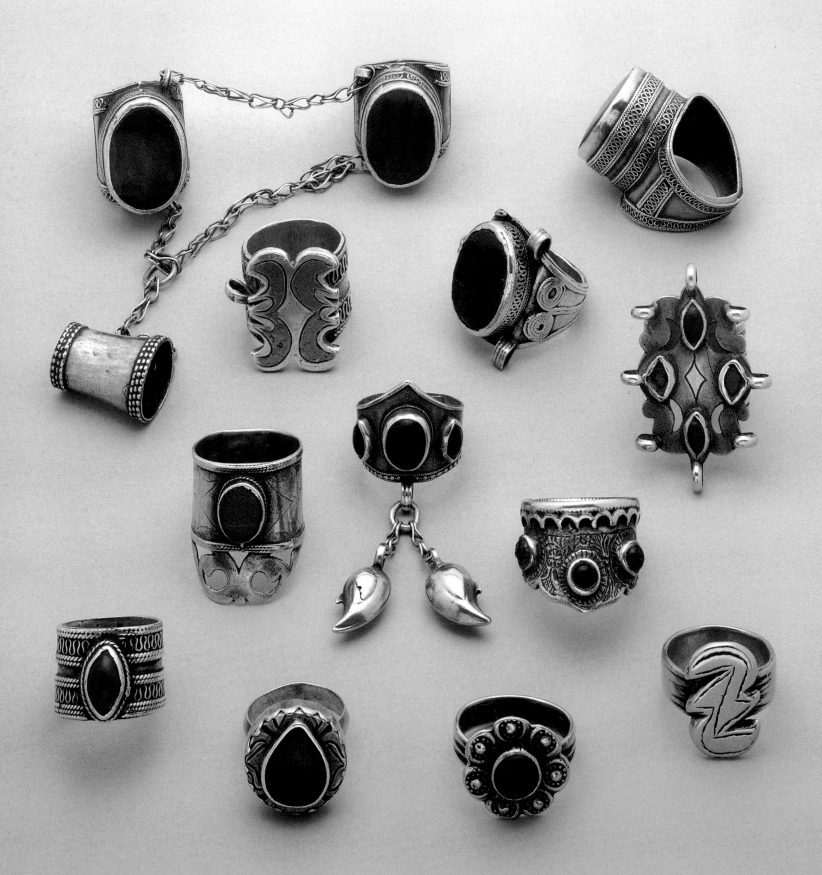

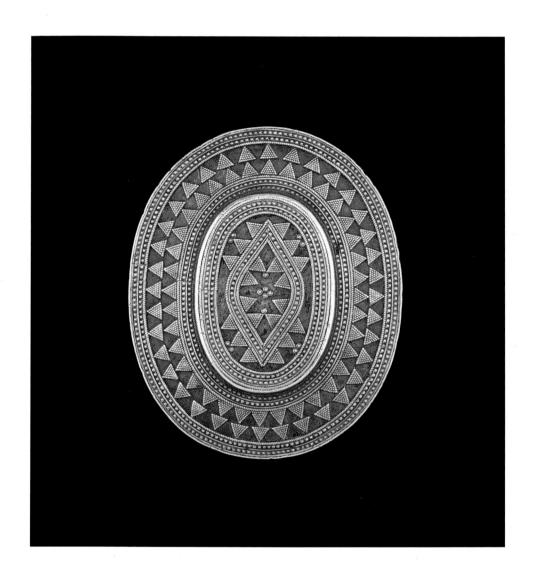

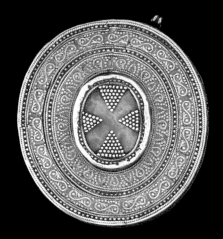
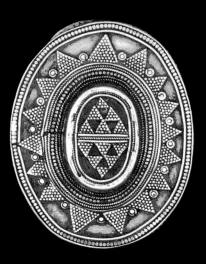
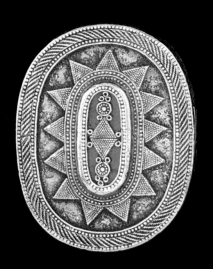
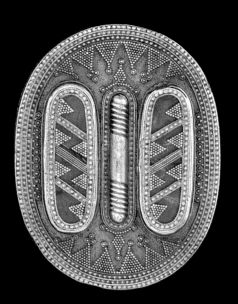

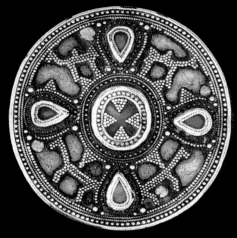
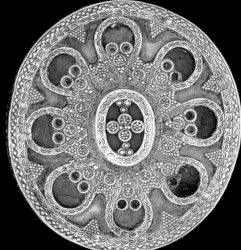
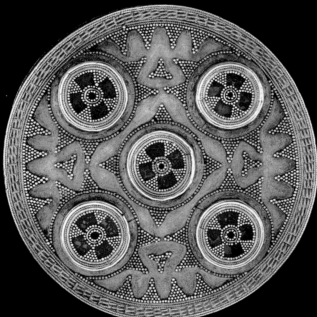
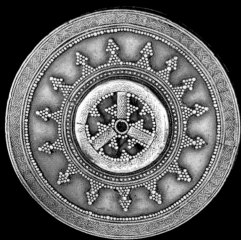
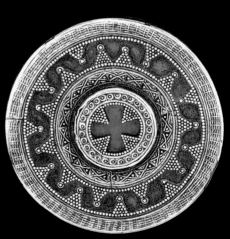

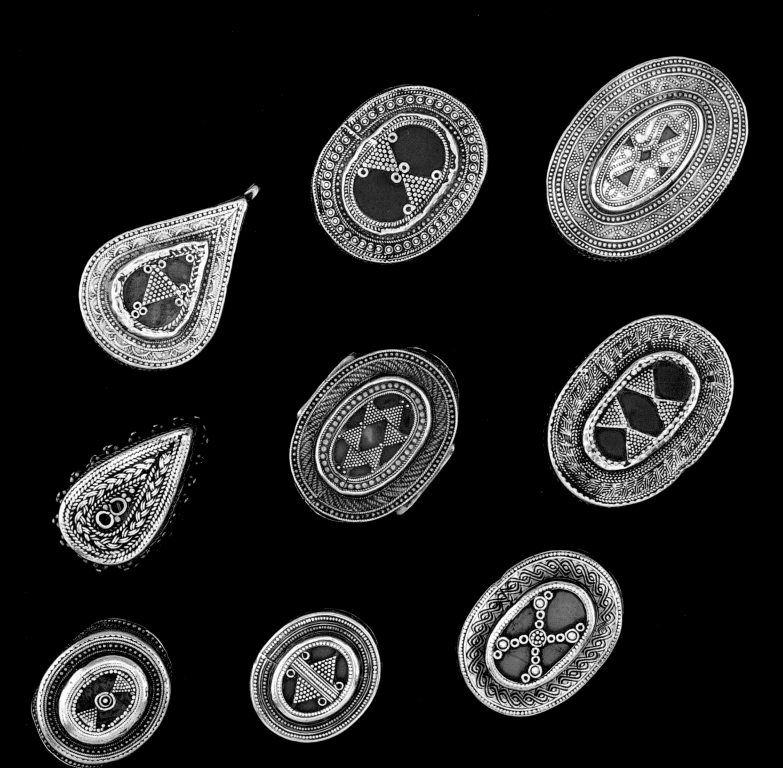

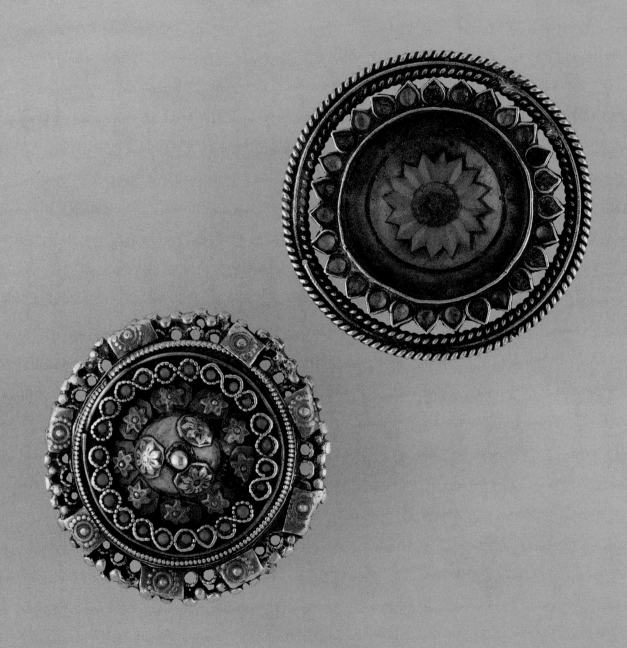

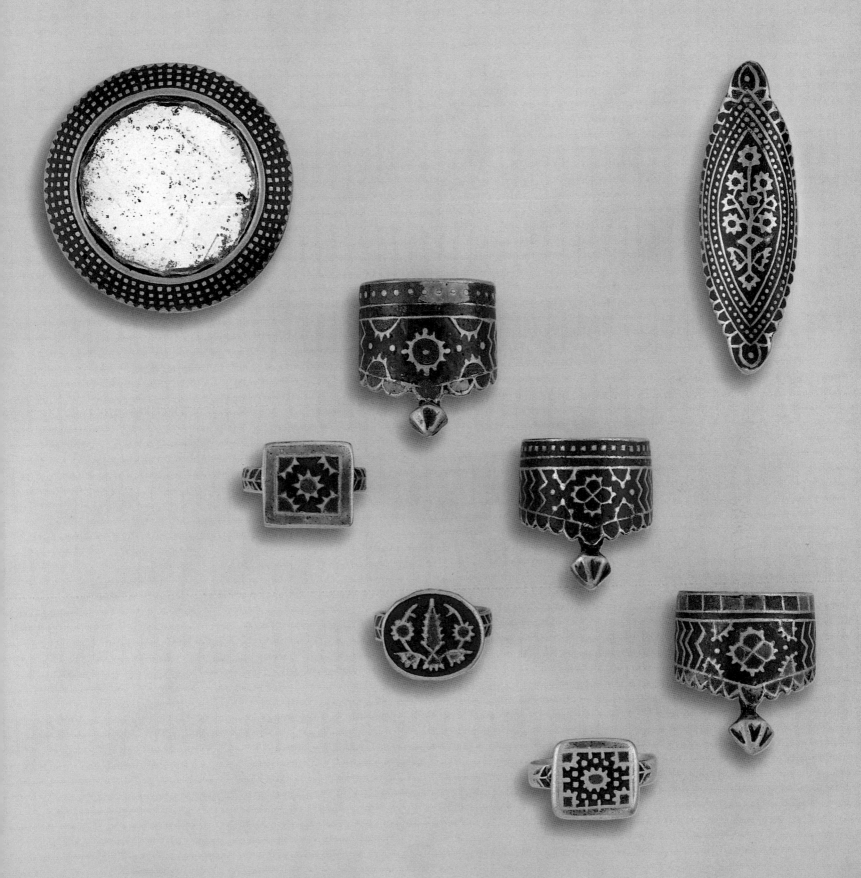

119

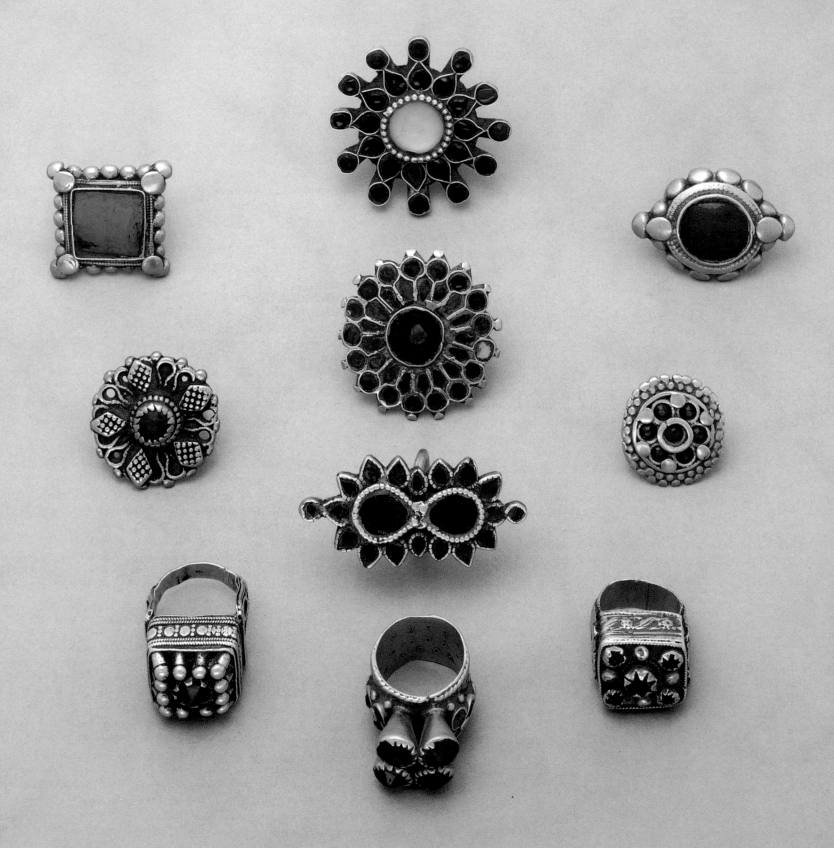

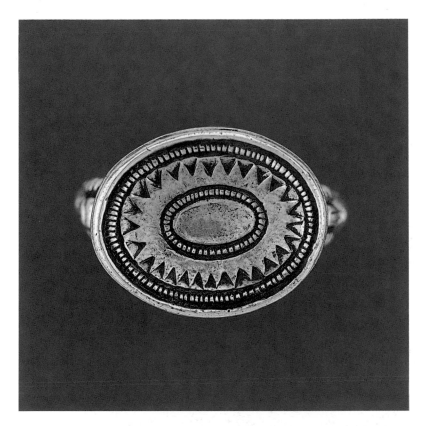

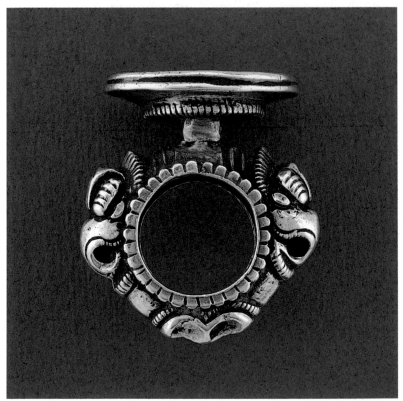

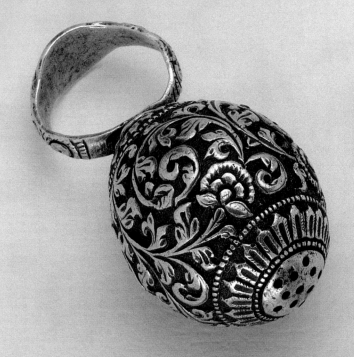

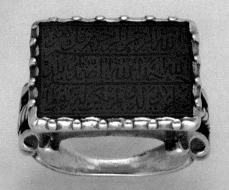

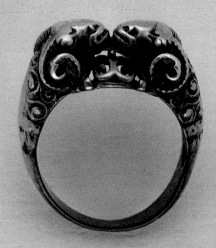

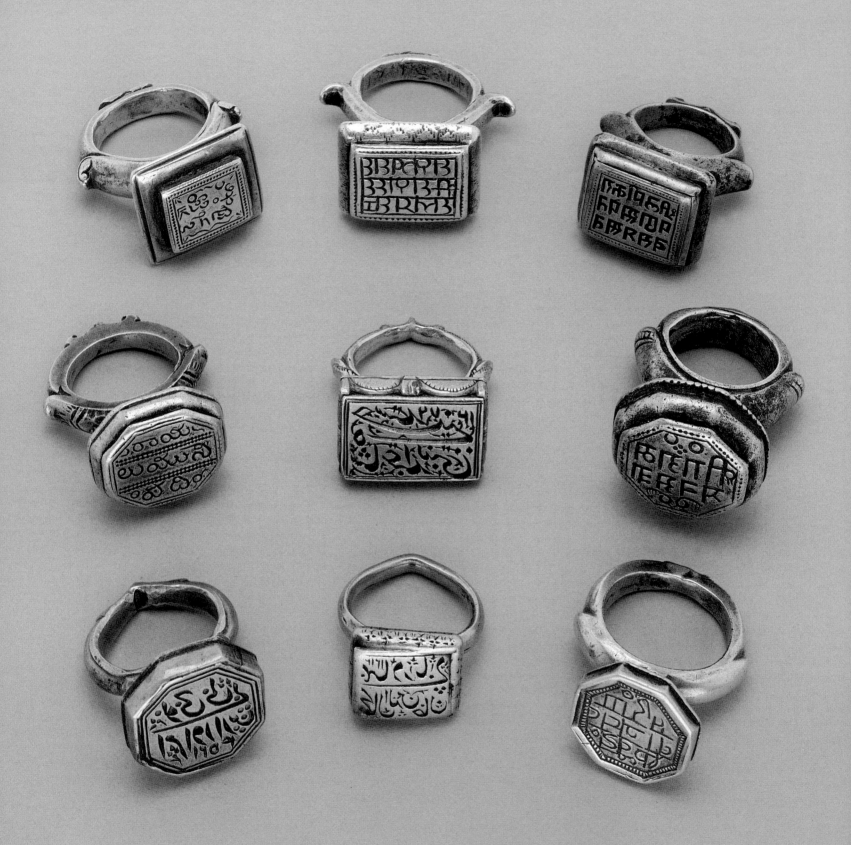

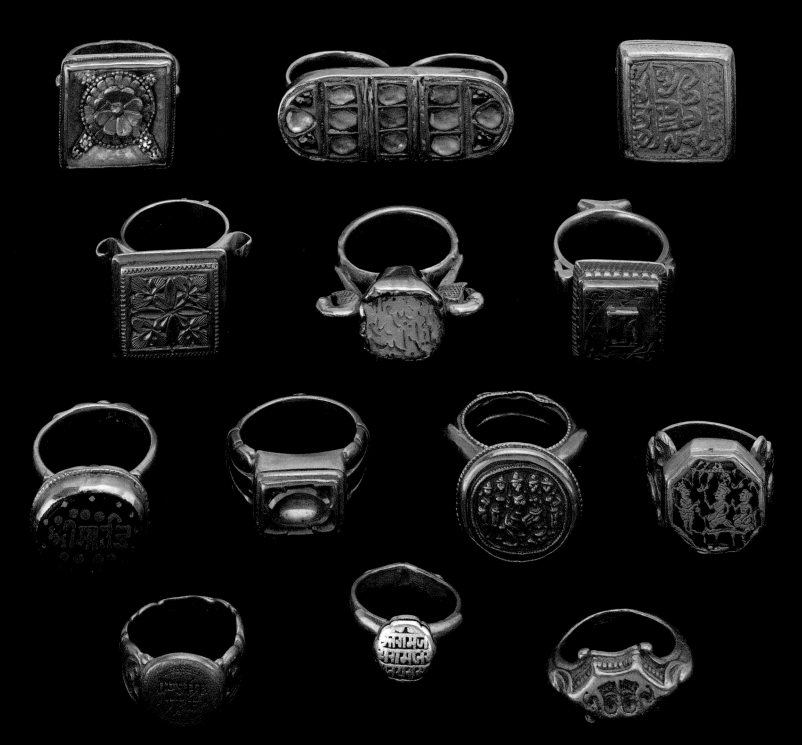

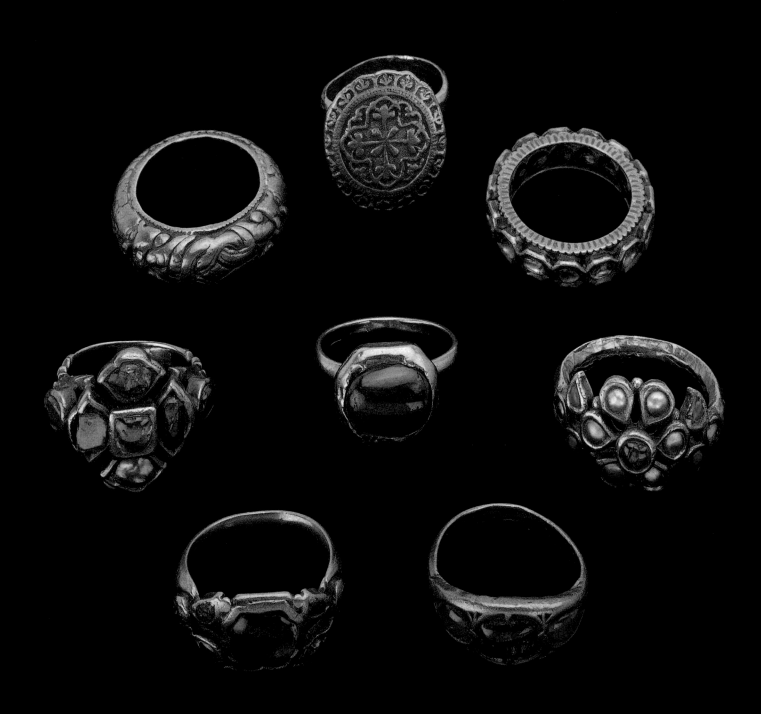

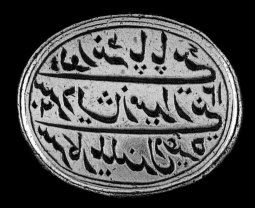
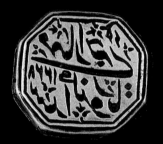
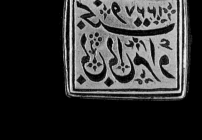
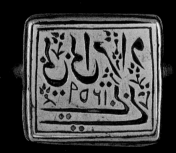
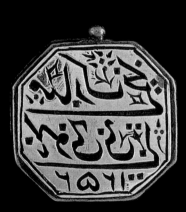
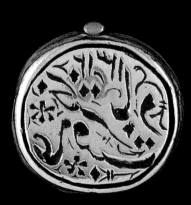
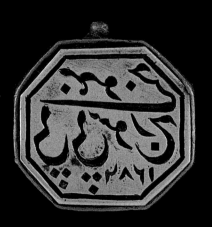

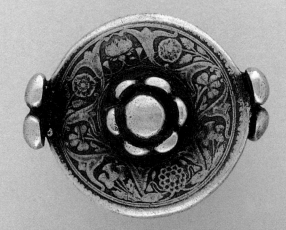

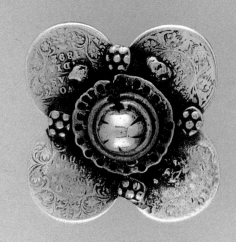
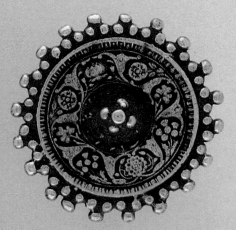

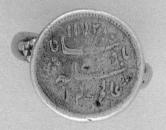

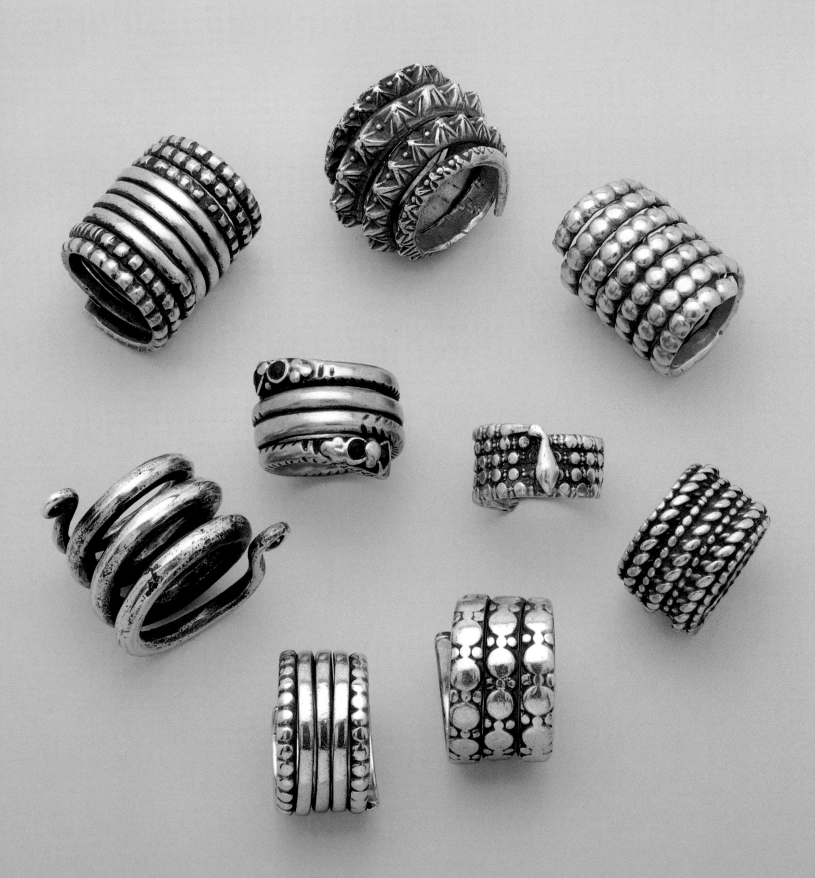

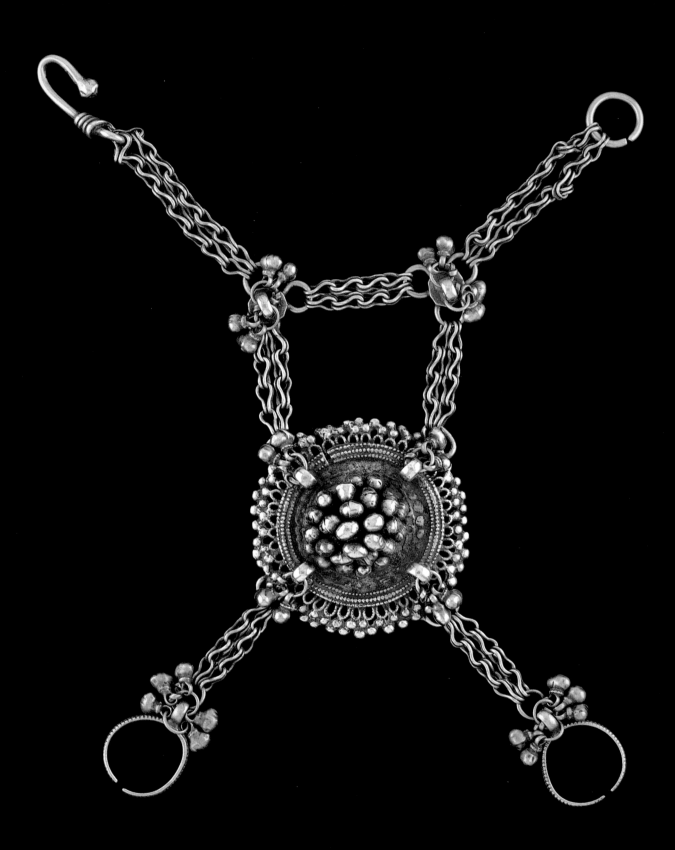

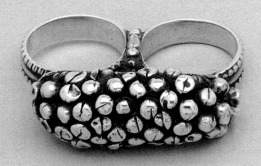
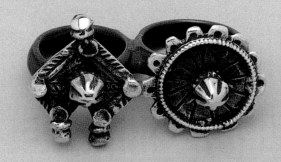
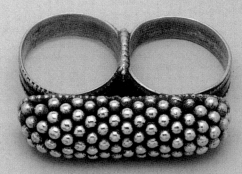
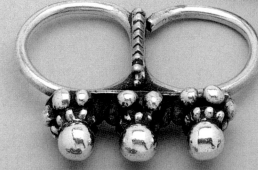
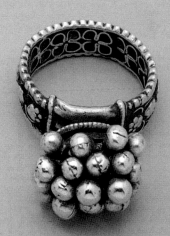
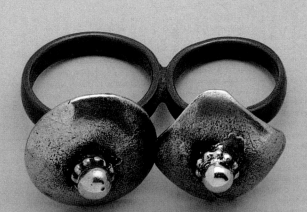

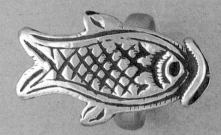

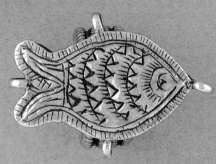

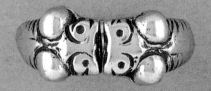

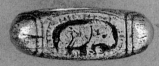

138

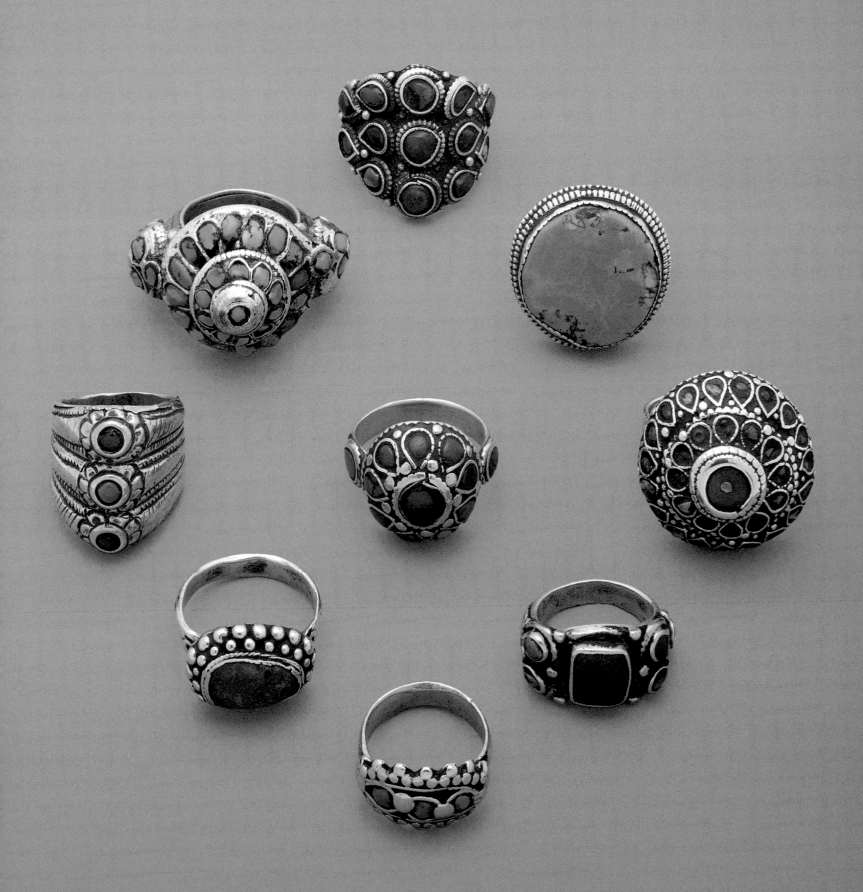

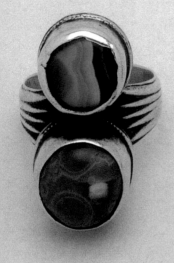
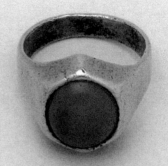
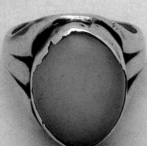
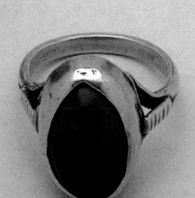
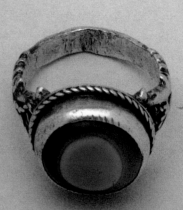

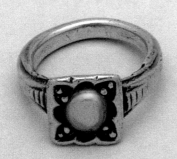
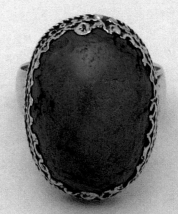
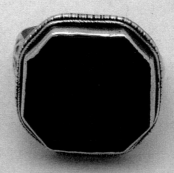
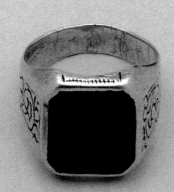
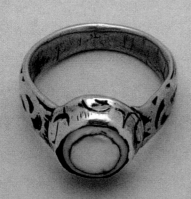

141

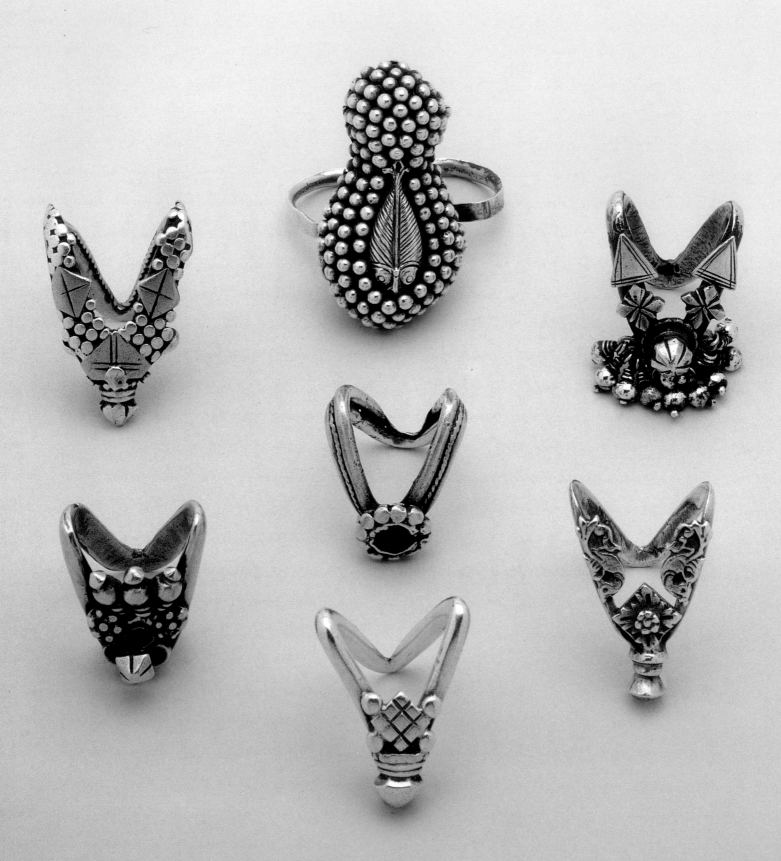

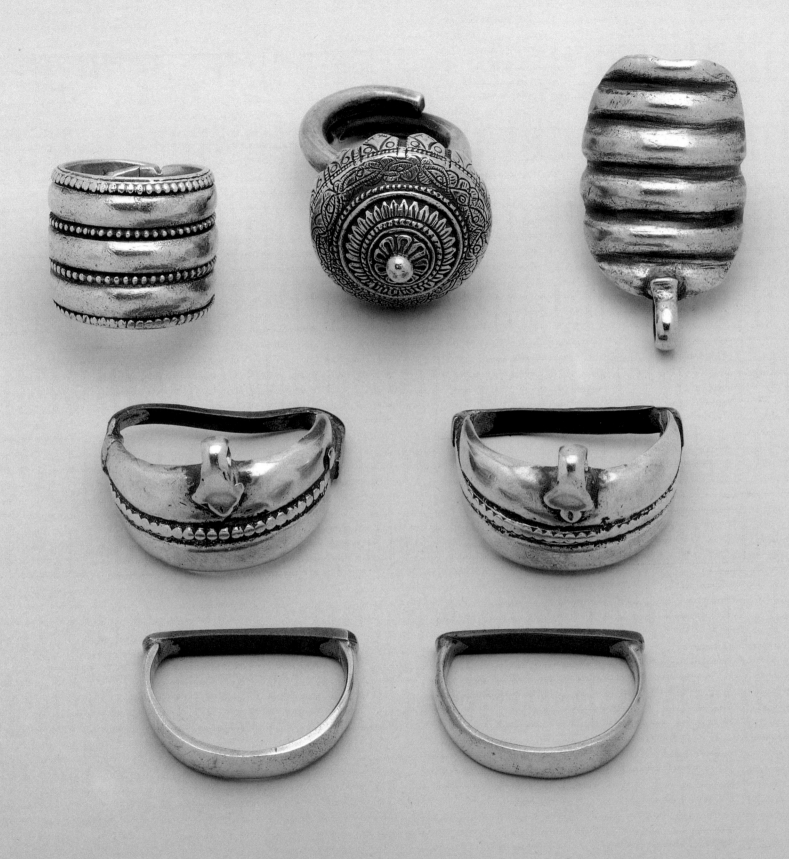

143

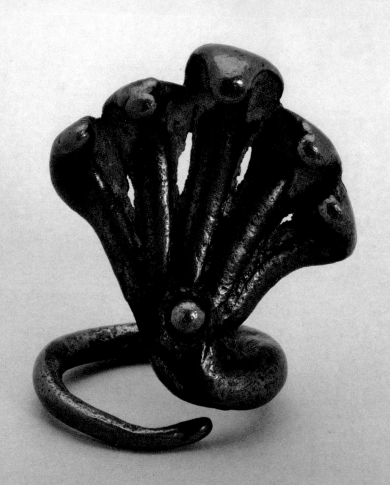

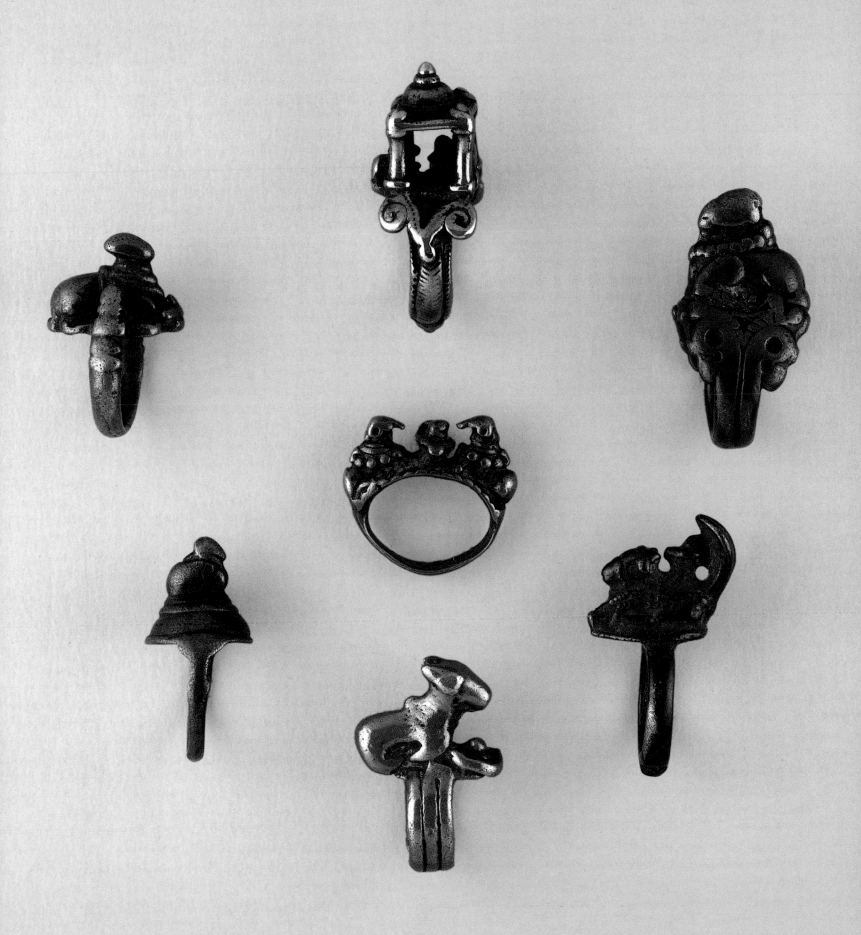

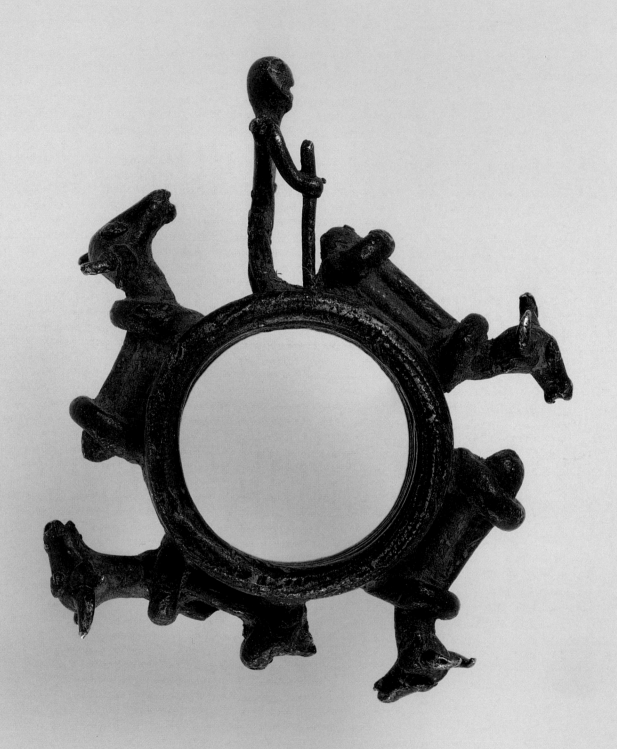

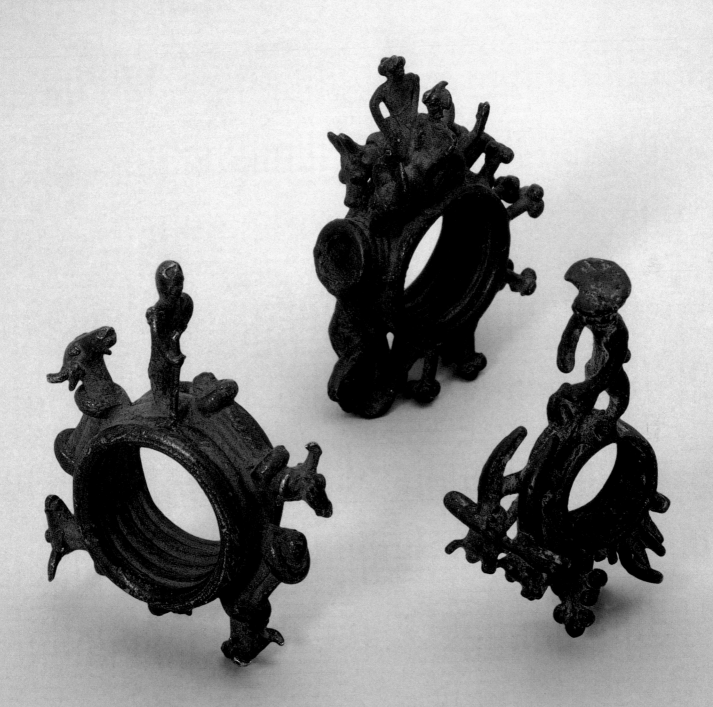

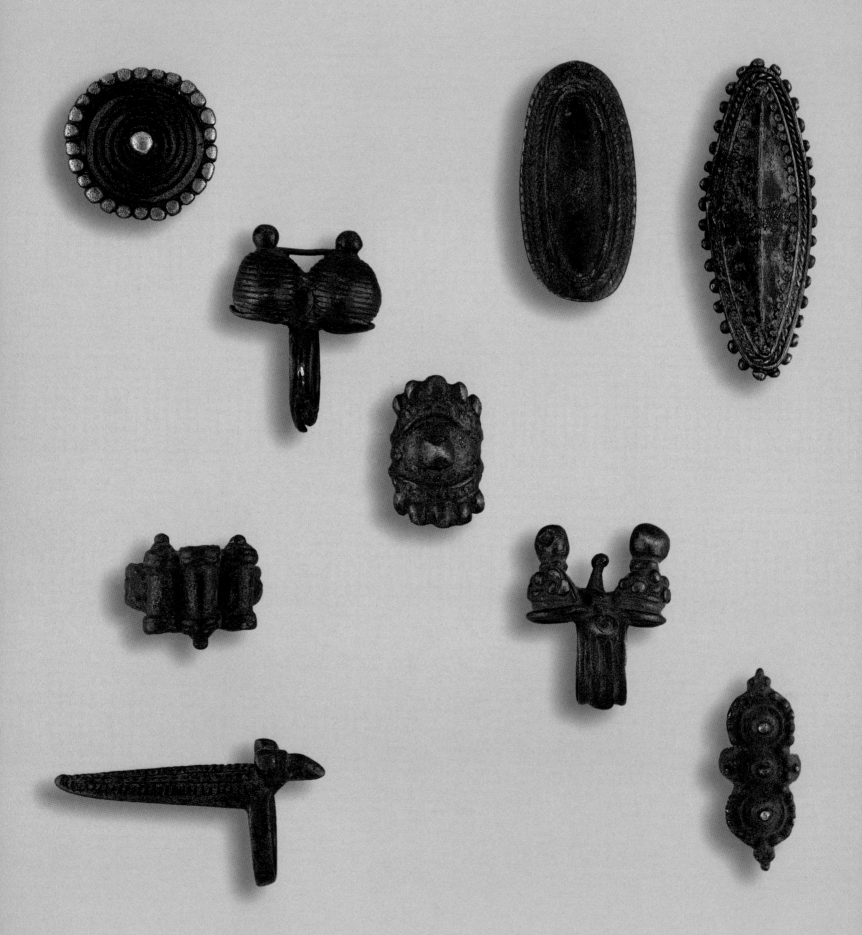

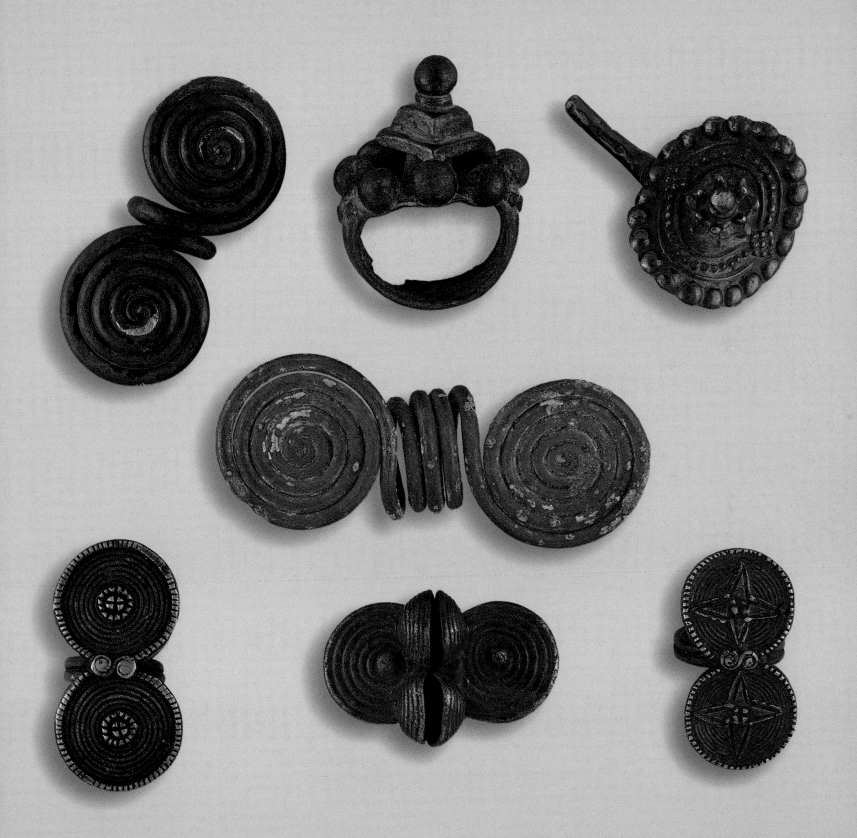

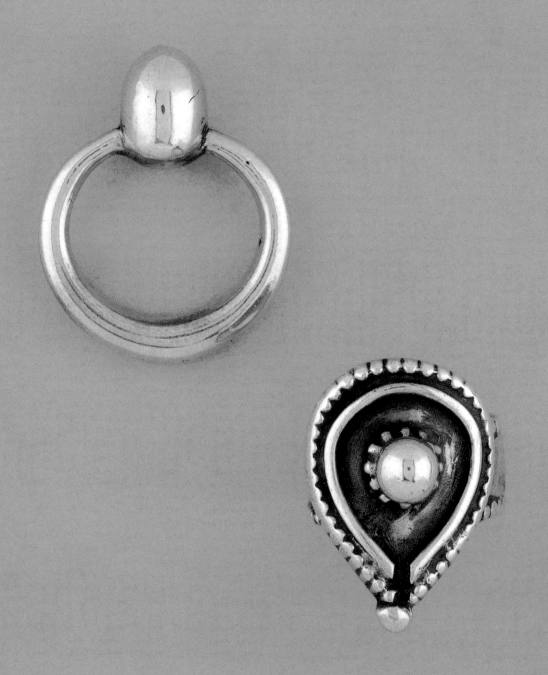

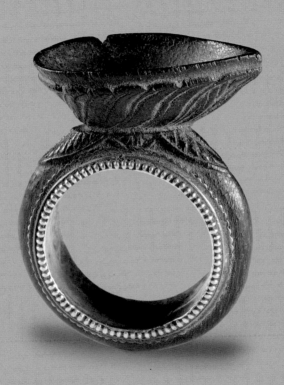

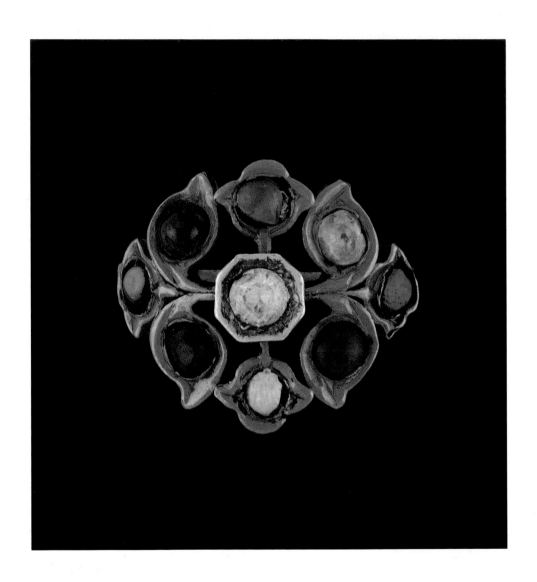

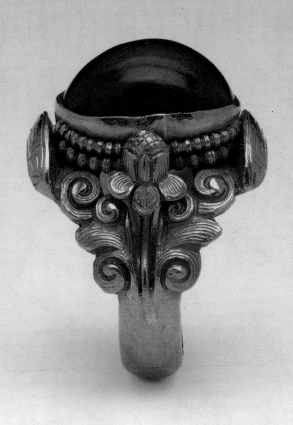

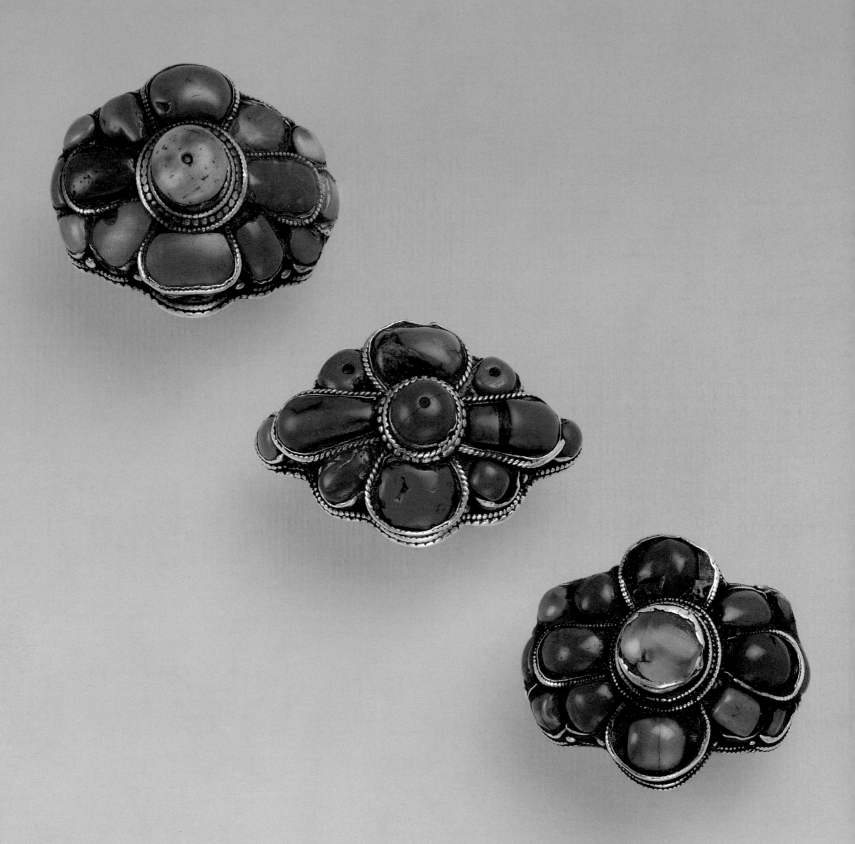

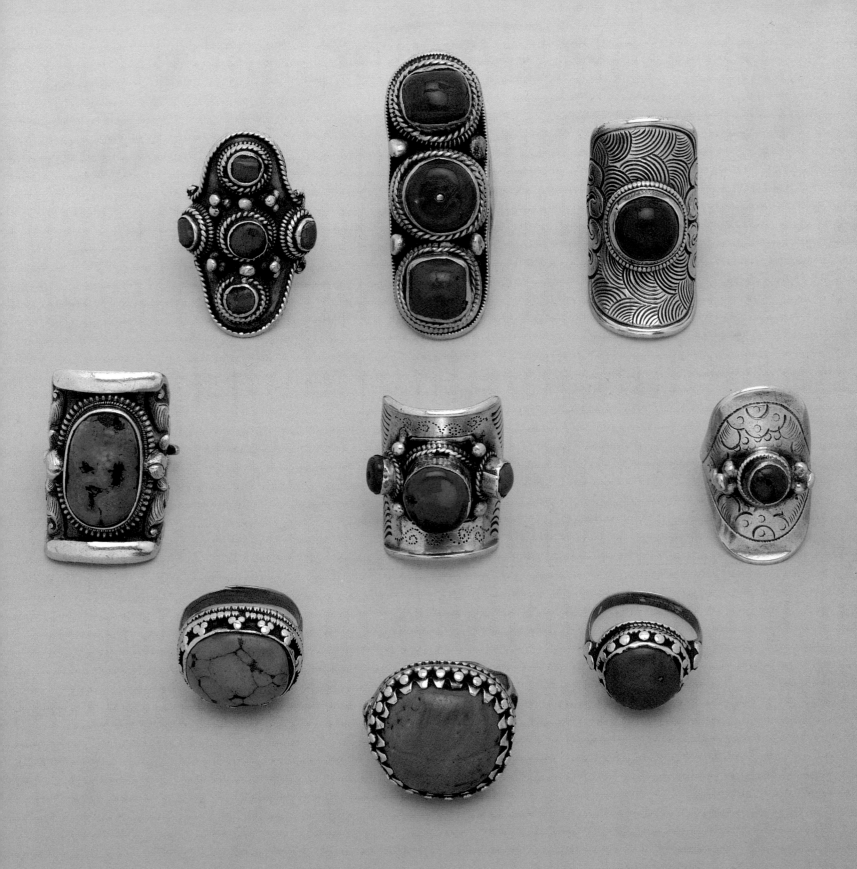

155

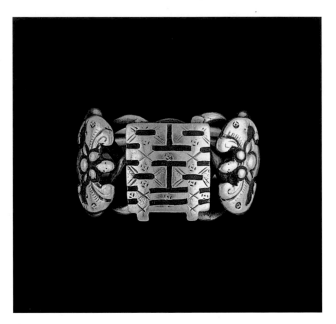
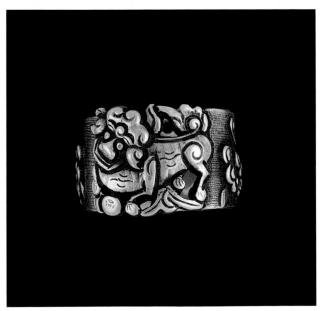
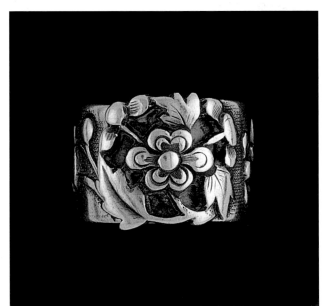

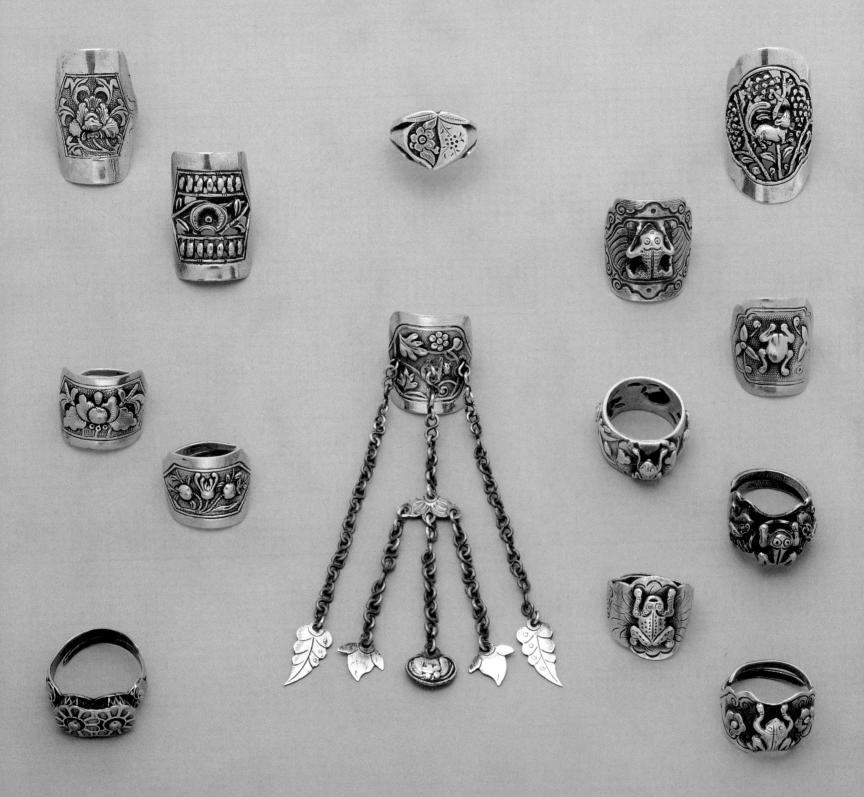

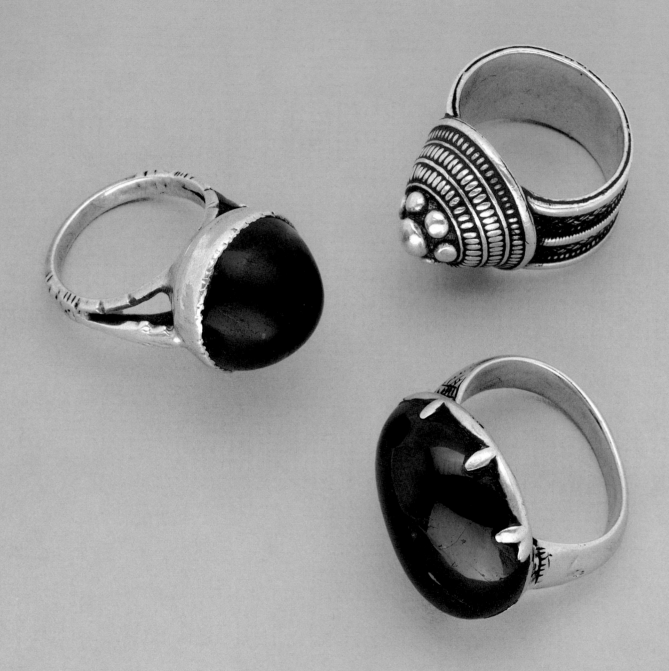

158

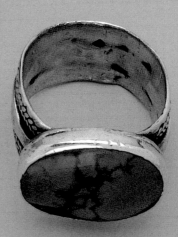

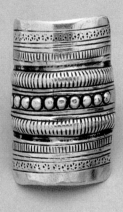
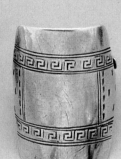
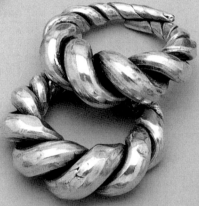
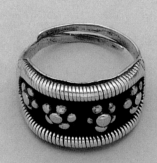
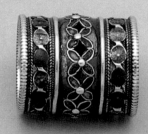
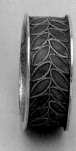
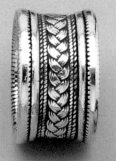
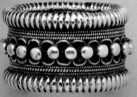

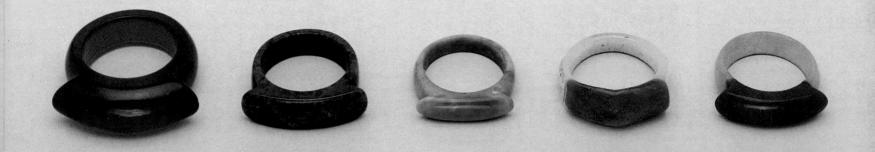

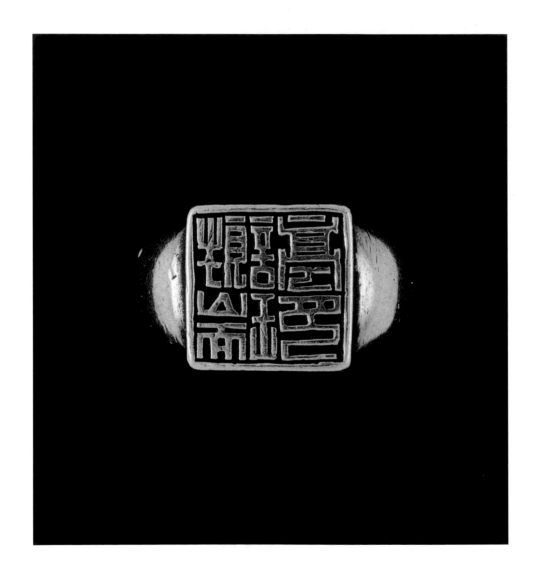

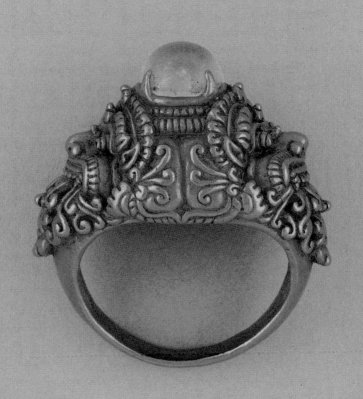

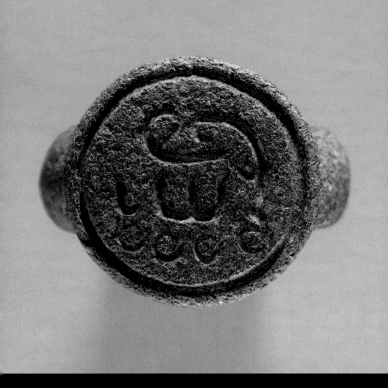

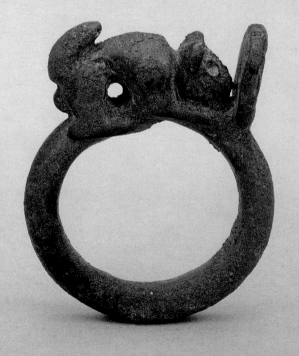

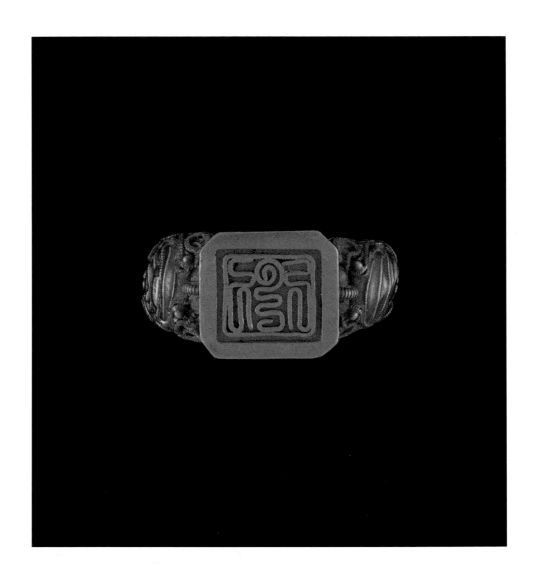

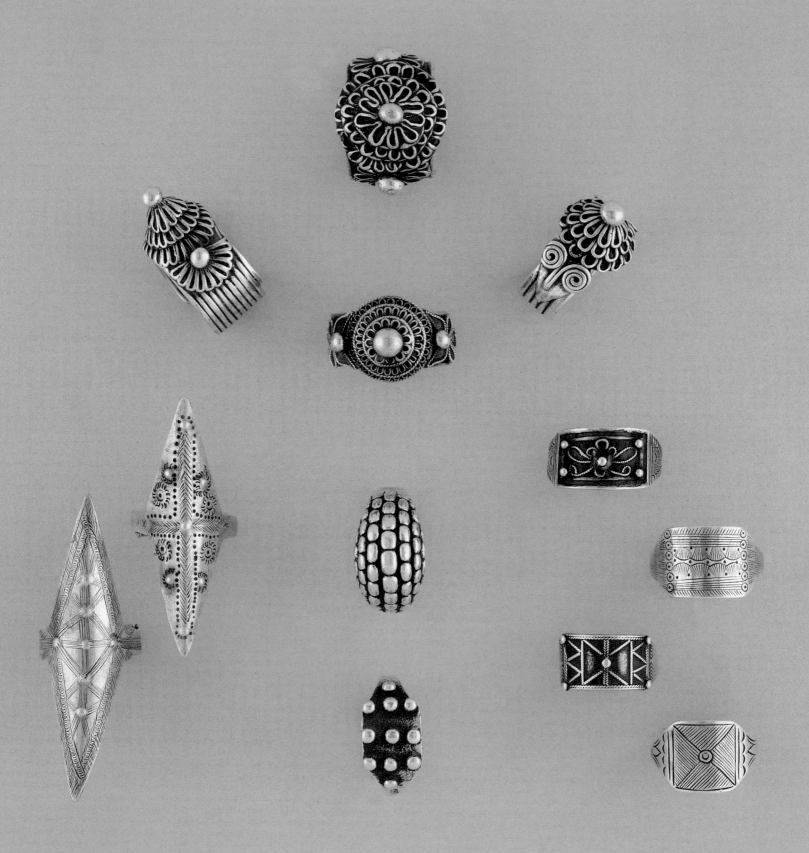

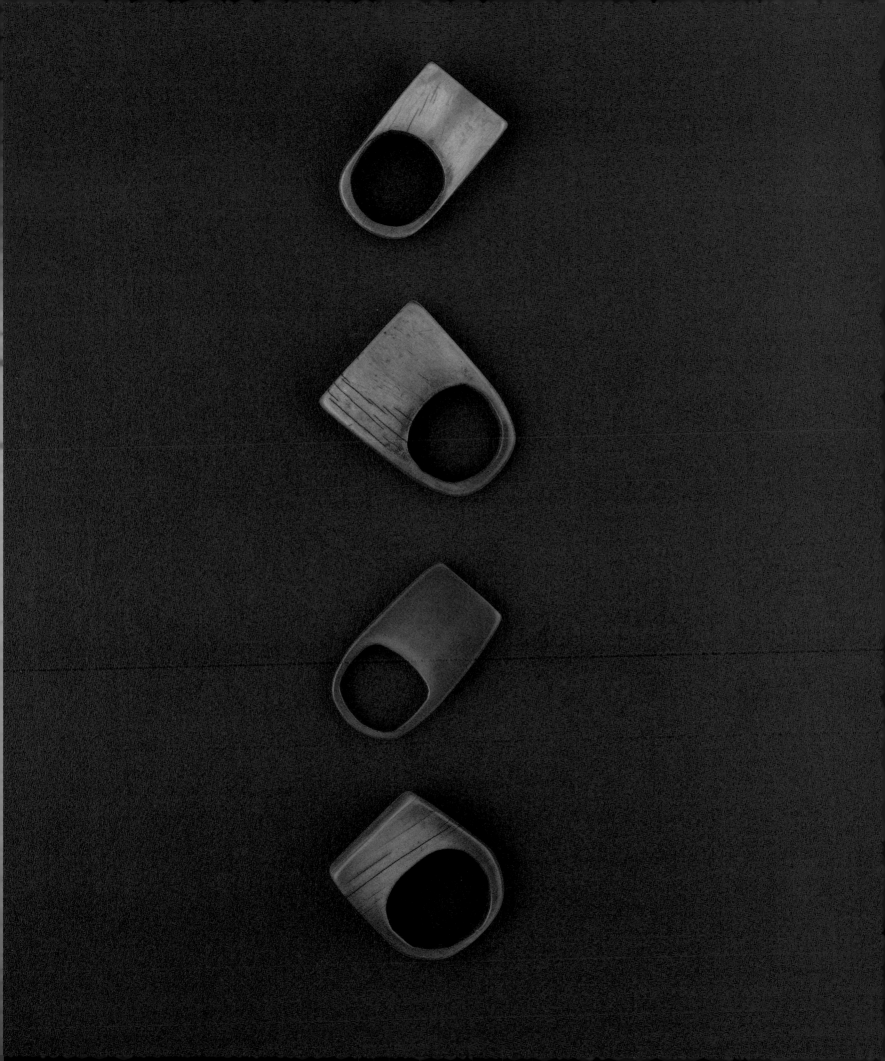

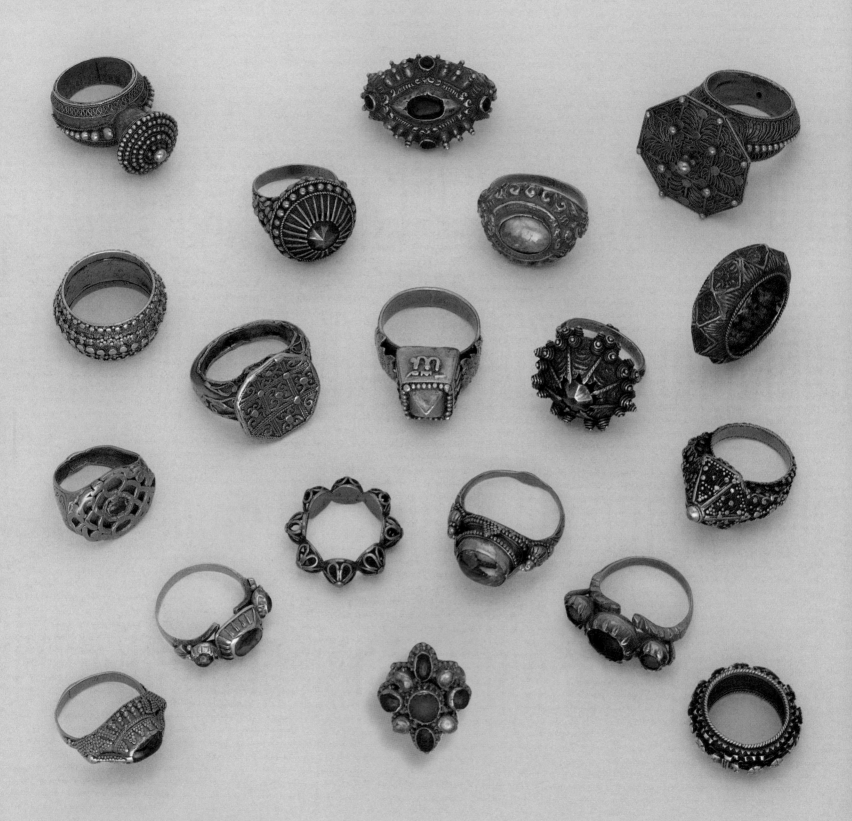

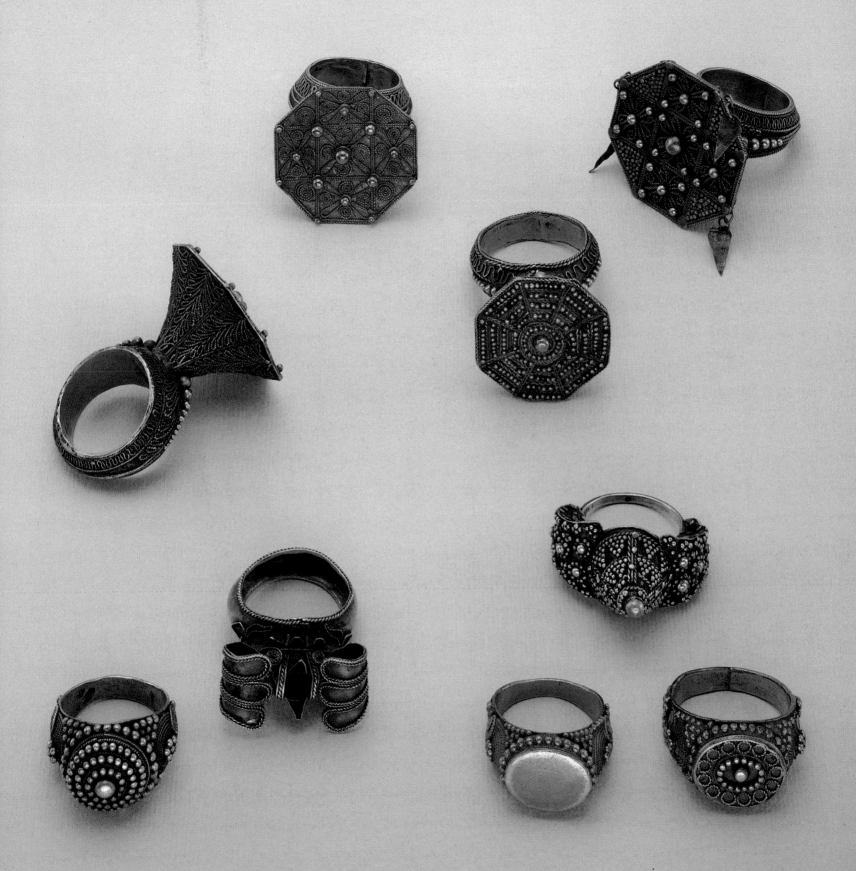

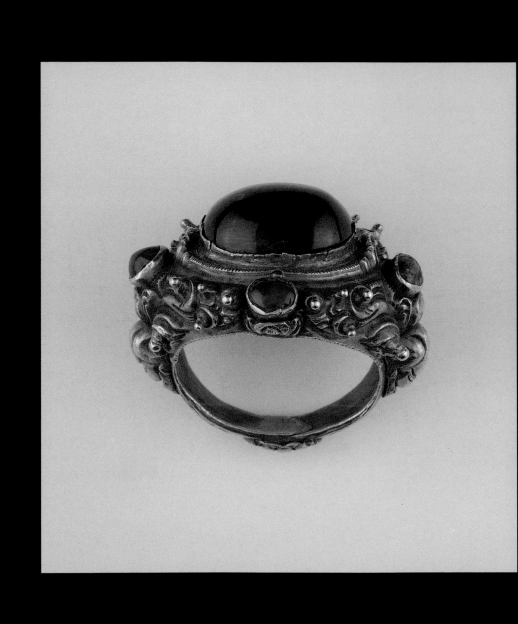

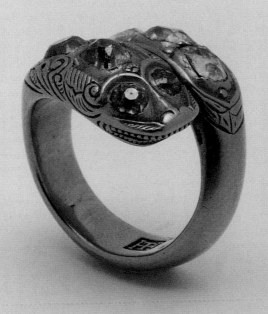

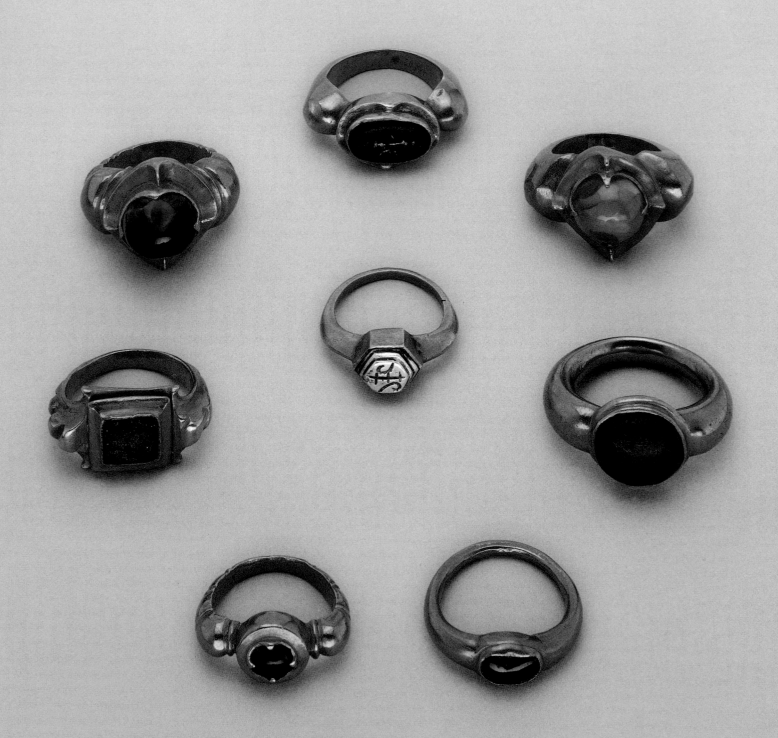

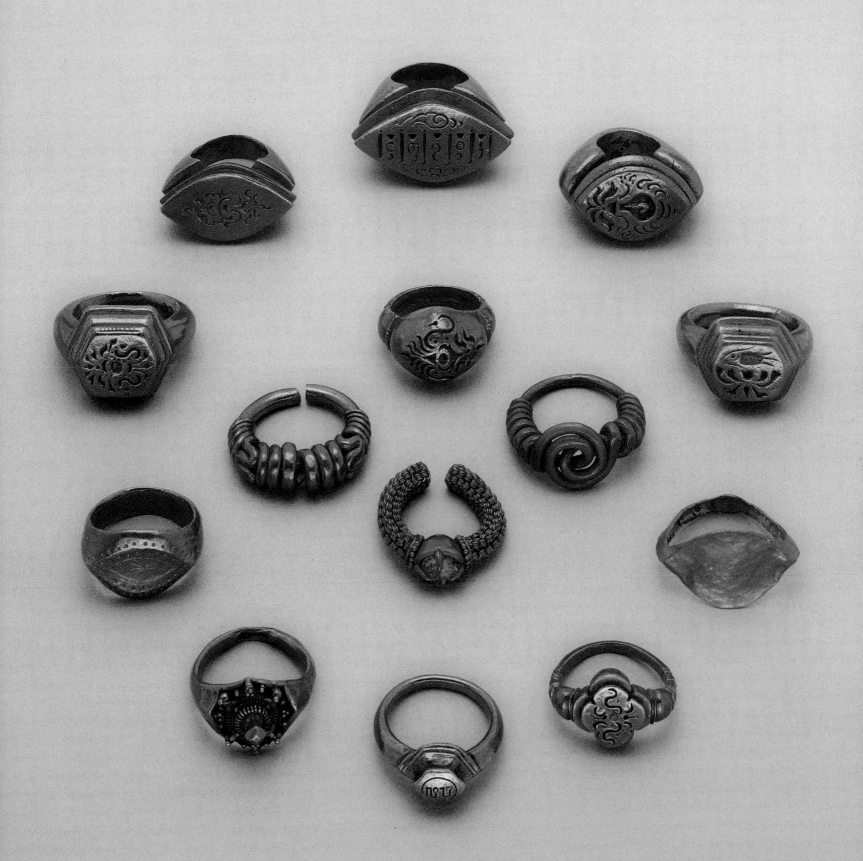

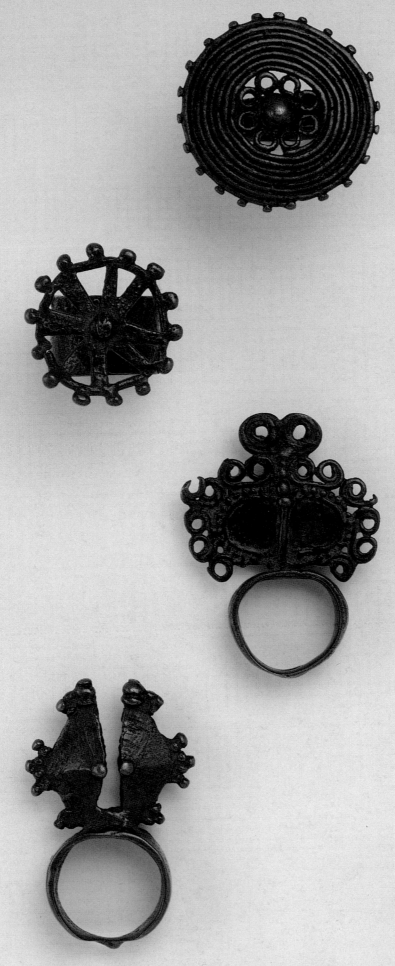

185

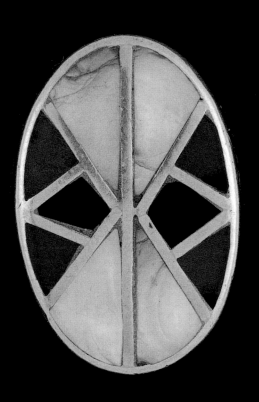

America

The lands of America

Contrary to other Indian populations of South America, the Araucanians or Mapuche from Chile were able to preserve their language and a certain cultural autonomy.

By the end of the 16th century, the rich silver mines of Potosi in Bolivia attracted the Spaniards who minted coins. In the course of time, silver coins reached the Araucanians who made jewellery out of them. Juan Ignacio Molina mentioned, at the end of the 18th century, the fact that all of the women's fingers were adorned with silver rings[1]. So their scarcity can surprise us today, museums and collections have very few, unlike other types of jewellery.

The Mapuche so appreciated the precious metal that jewellery was the only manual work practised by the men. Besides, the silversmith enjoyed great consideration in the community.

As for North American Indians, they worked silver much later. It is believed their interest in jewellery was owed to their contact with the Spaniards.

Navajo began by obtaining silver jewellery from the Plains Indians. Towards the middle of the 19th century, Mexicans taught them the rudiments of the craft. The first Navajo rings were plain strips of metal, sometimes incised, and shaped. After learning the soldering technique, they had more elaborate rings. The artisans adorned them with a plain-shaped bezel, often an oval, sometimes enhanced by a small stone. At the end of the century, they set their rings with turquoises, a stone they were particularly fond of.

The appreciation of turquoises goes way back to the pre-Columbian period. In the ancient Meso-American cultures, the turquoise is associated with fire and the sun. Thus the sun, armed with the turquoise snake, upon awaking hunts the moon. Is it not said that the Aztec emperor Montezuma offered turquoises as the most valuable goods to the conqueror Cortez?

A Navajo song tells us about their fondness for turquoises: "How joyously it neighs. Listen to the turquoise horse of the Sun God."[2]

[1] Hartmann, *Silberschmuck der Araukaner*, p. 30.
[2] Chevalier-Gheerbrant, *op. cit.*, pp. 982-983.

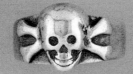

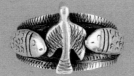

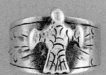

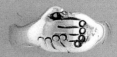

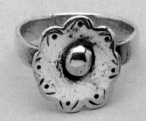 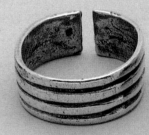 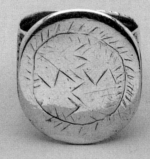 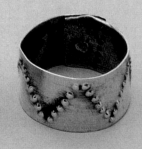 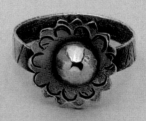

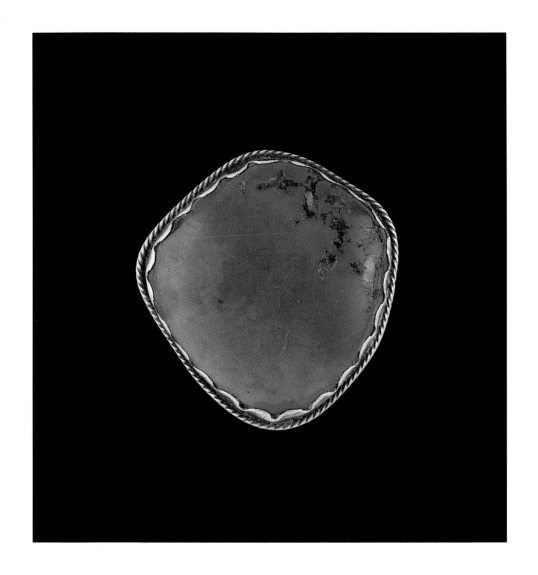

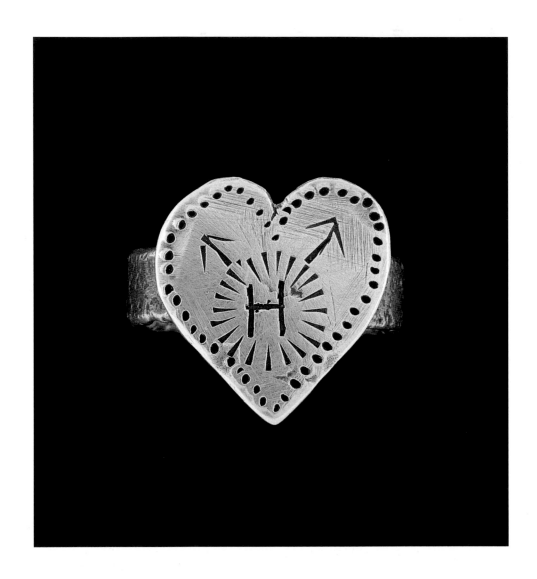

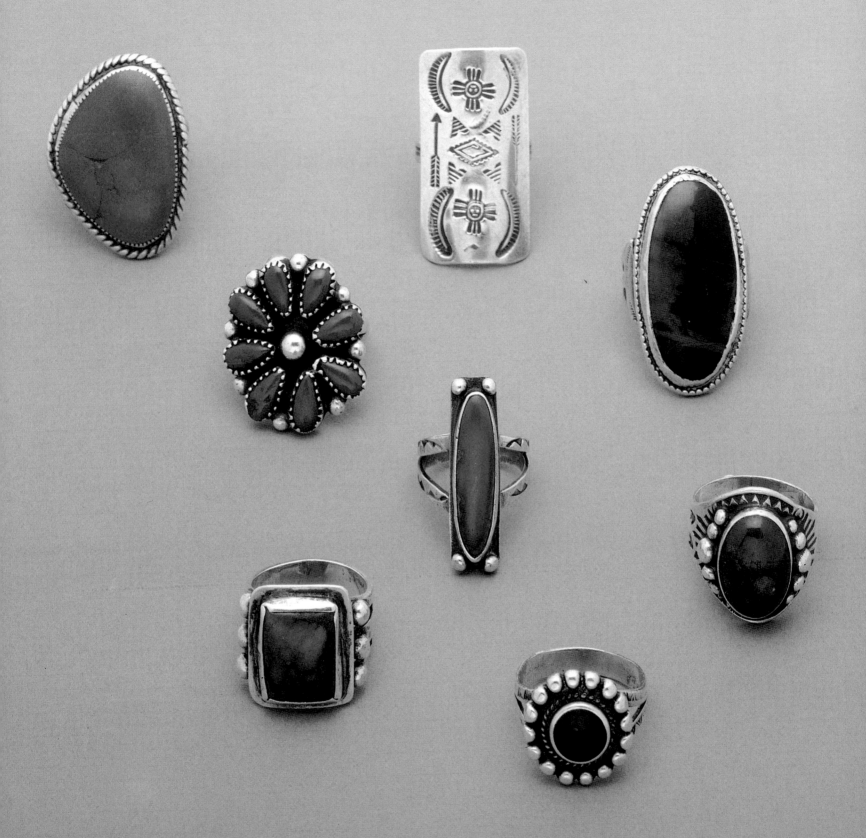

195

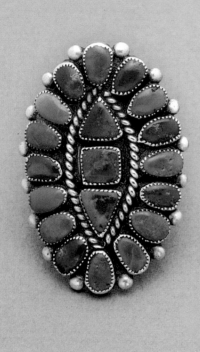

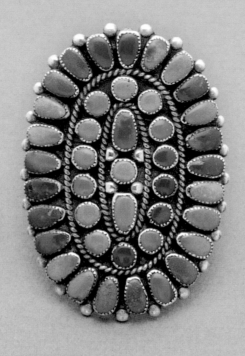
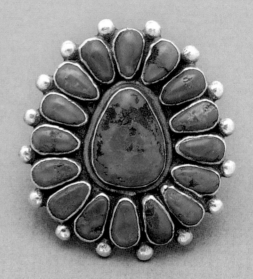
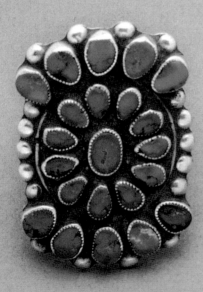
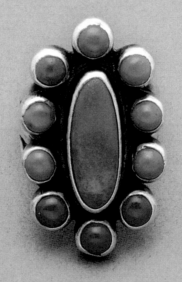
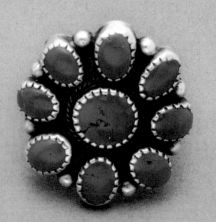

196

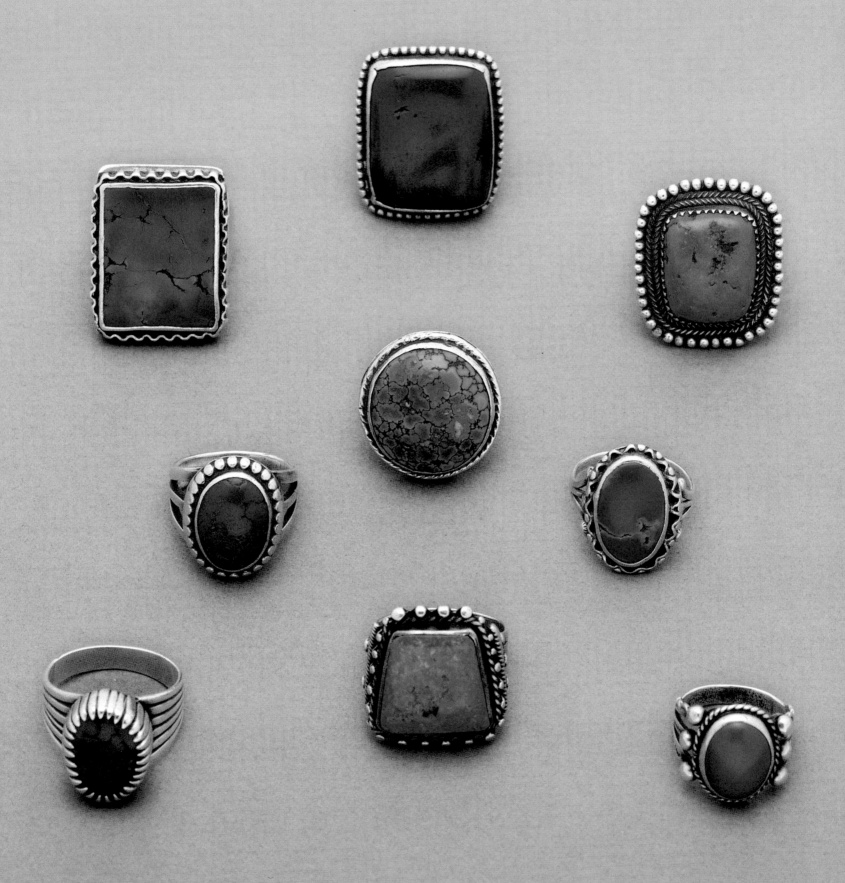

197

Captions

Africa

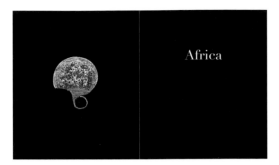

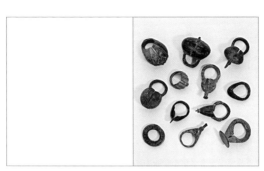

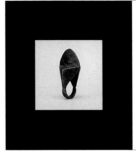

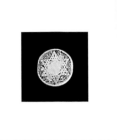

Page 8
Kenya, Uganda (Turkana, Karamojong)
Iron, copper; H. 104 mm
A defense weapon, the blade-ring has domestic uses.

Page 17
Mali, inner delta of the Niger, Djenne
Bronze; H. 55 mm
Archaeological excavation rings, 13th-14th centuries.

Page 18
Mali, inner delta of the Niger
Copper; H. 65 mm
Archaeological excavation ring.

Page 19
Morocco
Silver; D. 21 mm
Sherif ring with Solomon's seal of great symbolic value.

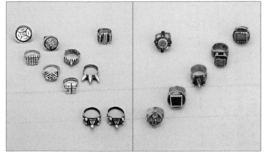

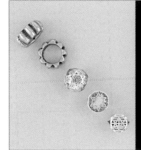

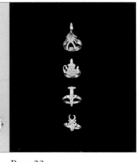

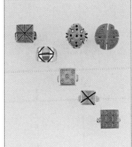

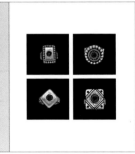

Page 20
Morocco, Anti-Atlas
Nielloed and enamelled silver; D. 28 mm
Pointing towards the four cardinal points, the cross is one of the four fundamental symbols, with the centre, the circle and the square.

Page 21
Morocco, Western Anti-Atlas
Enamelled silver, glass; L. 32 mm
Four points arranged around a central element: the reference to the number five is recurrent, recalling the five pillars of Islam.

Page 22
Morocco, pair of hoops: valley of the Todhra
Silver; D. 27 mm
Signs of wealth, coins are often incorporated in Islamic jewels. The three rings below are Sherif.

Page 23
Morocco
Silver; H. 27 mm
A scorpion ring protects, by analogy, from its evil power; the ram guarantees the return of the life cycle; the teapot refers to customary hospitality; the aeroplane is a sign of acculturation.

Page 24
Mauritania
Silver, enamel; D. 25 mm
The magic square has nine spaces in which the nine first numbers are written, the total on each side adding up to 15; the number 5 figuring in the middle.

Page 25
Morocco, Goulimine and Mauritania
Silver, enamel, glass beads; D. 20 mm
The beads, called Goulimine stones, suggest eyes, and by analogy are prophylactic.

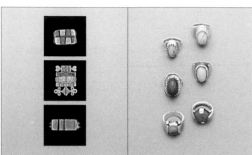
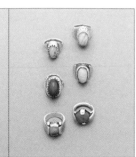
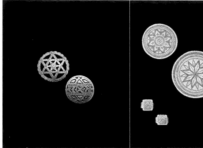
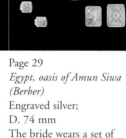
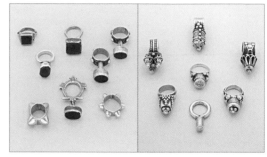

Page 26
Sahara (Tuareg) and Mauritania, copper rings
Copper, enamelled silver; L. 20 mm
Copper and brass are known for their medicinal properties, rings made of these materials are scarce among populations of the Sahara. The photo in the middle shows the top of the bezels of five rings.

Page 27
Senegal
Silver, agate; H. 47 mm
Pilgrim rings are the sign of having performed the journey to Mecca.

Page 28
Egypt, oasis of Amun Siwa (Berber)
Silver, enamel; D. 51 mm

Page 29
Egypt, oasis of Amun Siwa (Berber)
Engraved silver; D. 74 mm
The bride wears a set of eight rings, which is the number of cosmic balance, that of the cardinal directions and the intermediary directions.

Pages 30
Sudan (Rashaida)
Silver, cornelian; filigree and granulation; H. 52 mm
The cornelian contributes to childbirth.

Page 31
Sudan (Rashaida)
Silver, gilt silver; H. 44 mm
Highly ornate jewellery reflects the Arabic origins of the population. Rosettes are prophylactic against the evil eye.

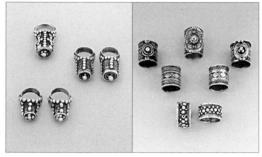
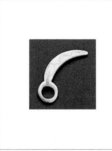
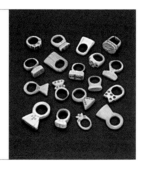
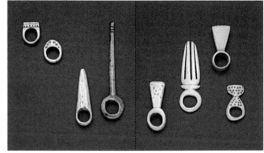

Pages 32
Sudan (Rashaida)
Silver, filigree and granulation; H. 52 mm

Page 33
Sudan (Rashaida)
Silver; H. 31 mm
Thumb rings worn in pairs; the one below was for the big toes.

Pages 34-35
Sudan (Dinka)
Carved and pyrographed ivory; H. 104 mm and 49 mm
In African art, dot-shaped motifs refer to something real: stars, grains of millet. In hunting areas, grouped dots sometimes represent the hunter or the game.

Pages 36-37
Sudan (Dinka) and Burkina Faso (Gurunsi), the conic ring
Ivory, carved, pyrographed; H. 150 mm and H. 110 mm
Very graphic, the most spectacular rings are the privilege of persons of rank.

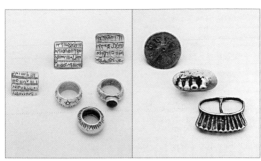

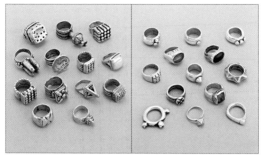

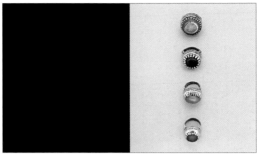

Page 38
Ethiopia (Oromo)
Silver, glass; H. 32 mm
Gheez writing is old
Ethiopian.

Page 39
Ethiopia (Sidamo)
Copper, brass; L. 47 mm
The marked preference of
southern tribes for these
metals is a sign of their
proximity to Black Africa.

Pages 40-41
Ethiopia
Silver, stone, glass;
L. 50 mm and L. 36 mm
The ring above, in the
middle, might be phallic
and appreciated by the
Hareri for its magic
properties. The two rings
decorated with a cross are
proof of religious
membership.

Page 43
Niger and Chad
Silver, stone and glass;
H. 35 mm

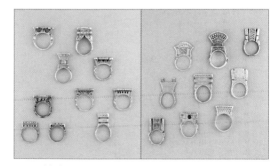

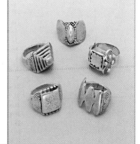

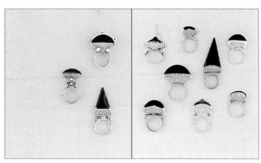

Pages 44-45
Sahara (Tuareg)
Silver, enamel; H. 28 mm
and 48 mm
Tisek rings with a great
purity of form, highly
structured, have a severe
grandeur. Men and
women often exchange
them as a token of
affection.

Page 46
Mali (Peul)
Silver; H. 39 mm
The highly structured
form and more ornate
decoration are a synthesis
of Tuareg and Moorish
arts.

Page 47
Mali (Peul)
Silver; H. 23 mm
Although some attribute
them to the Tuareg.

Pages 48-49
Sahara (Tuareg)
Silver, cornelian;
H. 66 mm and 72 mm
The prophylaxy of the
cornelian is valuable in
particularly hostile
surroundings.

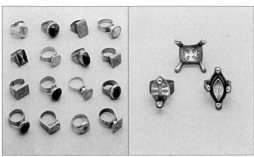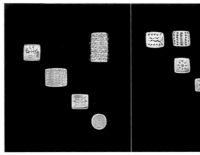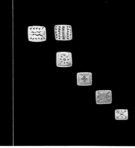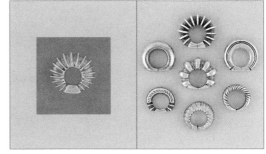

Page 50
Mali, Niger (Peul)
Silver, cornelian, glass;
H. 37 mm
Owing to the nomadism
practised by several of its
populations, the exact
origin of Sahel rings can
be difficult to determine.

Page 51
Mali (Peul)
Solid incised silver.
H.35mm
These rings might recall
the camel's saddle. The
Peuls have complex
traditions, all the more
interesting that they
sometimes match those of
other populations.

Page 52
Mali (Tuareg) and Niger,
the one at the bottom
Solid, incised silver;
H. 42 mm
Marabout rings, talisman
incised with magic
symbols.

Page 53
Mali (Peul)
Incised silver; L. 27 mm
Men's rings.

Pages 54-55
Mali (Fulani)
Silver; H. 55 mm
and D. 45 mm
The biggest ring is a lost
wax, the others are flat-
cast and then forged.

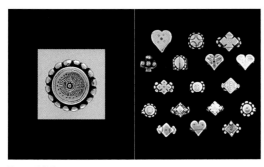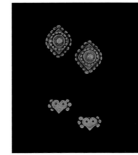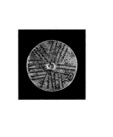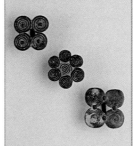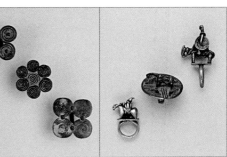

Pages 56-57
Mali (Sarakole)
Silver, copper inlays;
D. 27 mm and L. 32 mm
Motifs inspired by card
games.

Page 58
Mali (Sarakole)
Silver, copper inlays;
H. 31 mm
Toe rings worn in pairs.

Page 59
Mali (Dogon)
Aluminium, copper;
D. 44 mm
Aluminium recovered
from aeroplane wrecks or
household appliances of
European origin.

Page 60
Mali (Dogon)
Bronze; D. 41 mm.
Marshes waterlilies that
can be seen after heavy
downpours.

Page 61
Mali (Dogon) the round
ring, *Seno plain*
Bronze; H. 71 mm.
Horsemen's rings would
have been worn by the
Hogon, the religious chief,
the blacksmith or persons
of rank.

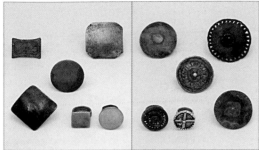
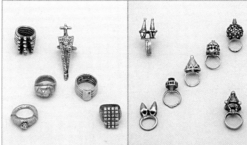
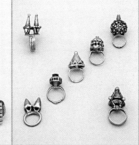
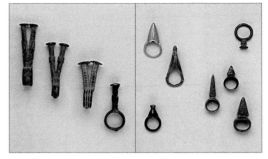

Page 62
Mali (Dogon)
Bronze; L. 55 mm
The big bronze rings
of West Africa are the
privilege of men.

Page 63
Mali (Dogon)
Bronze; D. 66 mm
The two big ones on the
right can be found among
the Bobo of Burkina Faso.

Page 64
Burkina Faso (Lobi)
above, *Ghana (Akan)*
the four below
Bronze; H. 71 mm
The big ring represents
a knife in its sheath.

Page 65
*Mali (Dogon), Cameroon
(Tikar)* upper right
Bronze; H. 54 mm
Tikar granary and bird's
nest rings, the latter
theme is equally a favorite
of the Akan.

Page 66
Mali (Dogon)
Bronze; H. 74 mm.

Page 67
Mali (Dogon)
Bronze; H. 61 mm.

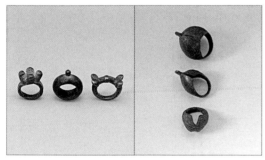
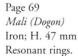
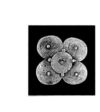
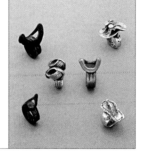
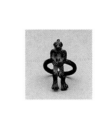
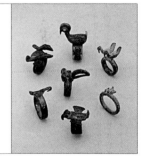

Page 68
Ivory Coast (Senufo)
Bronze; L. 37 mm
Fused cannons, ingots
and shackles of European
origin were used by
blacksmiths as raw
material.

Page 69
Mali (Dogon)
Iron; H. 47 mm
Resonant rings.

Page 70
Mali (Dogon)
Bronze; L. 47 mm
Only a scientific test
enables to determine the
exact composition of a
copper-based alloy. We
have chosen the wide-
spread term "bronze".
Nearly all the large
bronze rings of West
Africa are lost wax.

Page 71
*Mali (Dogon) Ivory Coast
(Senufo)*
Bronze; H. 45 mm
Dogon sandals and
Senufo ankle-bracelets
worn by women in actual
size, but by men in rings.

Page 72
Ivory Coast (Senufo)
Bronze; H. 43 mm
Senufo women can be
soothsayers.

Page 73
*Ivory Coast (Senufo)
Burkina Faso (Bobo)*
centre and above
Bronze; H. 57 mm
In Senufo sacred
symbolism, the bird
is associated with the
heavenly powers and
equally with planting.

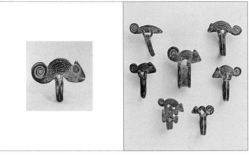

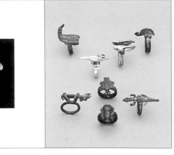

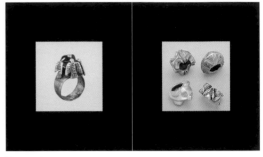

Pages 74-75
Ivory Coast (Senufo)
centre and below left
and Burkina Faso (Lobi)
Bronze; H. 54 mm and
L. 85 mm
In its symbolism, the
chameleon proceeds from
cosmic order to ethics,
from demiurge to the
animal, whose physical
features and behaviour
serve as images for the
initiator's teachings.

Page 76
Ivory Coast (Senufo)
Bronze; H. 40 mm

Page 77
Ivory Coast (Senufo)
Bronze; L. 50 mm
Thumb rings worn at
divination ceremonies
assembling three of the
five primordial animals of
Creation: the chameleon,
the turtle and the
crocodile.

Pages 78-79
Ghana (Ashanti)
Silver, on left, gold on
right; H. 35 mm
Ostentatory marks of
power, worn sometimes
on all fingers at once, that
play on metaphors and
express aphorisms, such
as "the bird's parent is the
one beside it".

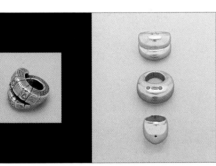

Page 80
Nigeria
Cast and incised silver;
D. 34 mm.

Page 81
Cameroon (Mandara)
Silver, cast; L. 35 mm.

Asia

Page 82
Indonesia, Java
Gold; H. 27 mm
Ring with *makala*.

Page 95
Israel
Chased silver; H. 70 mm
Jewish bride's ring, no
longer worn after the
ceremony. The bezel
shaped like an edifice
might recall a synagogue
or the Temple of
Jerusalem.

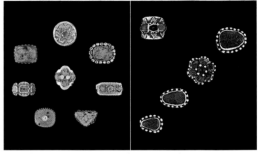

Pages 96-97
Saudi Arabia (Bedouin)
Gold, gilt silver,
turquoise, on left, silver
on right; L. 26 mm
and 29 mm
Many types of rings,
reflecting the custom of
wearing a different style
ring on each finger.

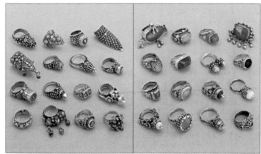

Pages 98-99
Yemen (Bedouin)
Silver, coral, cornelian,
glass; H. 54 mm
L. 60 mm
The bride wears the
triangular ring on her left
thumb. The pendants
chase the evil spirits.
Some of these rings
were much sought-after
by Sudan Rashaidas.

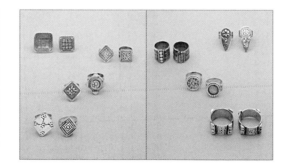

Pages 100-101
Oman (Bedouin)
Silver, gold; H. 27 mm
and 32 mm
Married women wore a
set of ten rings, an
appropriate form for each
finger; the toe rings,
below, on right. were
worn in pairs.

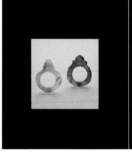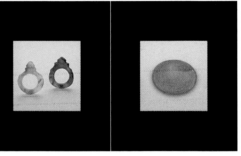

Page 102
*Iran, Timurid period,
14ᵗʰ-15ᵗʰ century*
Cornelian; H. 40 mm
Hololithic rings proving a
long tradition of stone-
working.

Page 103
*Iran, Safavid period, late
15ᵗʰ-mid. 18ᵗʰ centuries*
Agate, silver; L. 27 mm
This ring reflects the
collaboration between the
lapidary and the
calligrapher.

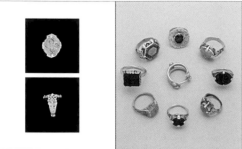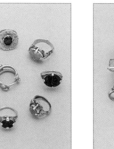

Pages 104-105
Iran and Turkey, Anatolia,
Seljuq period, 11ᵗʰ-12ᵗʰ
century
Gold, niello and stones;
H. 27 mm L. 23 mm
Ensemble attesting the
mastering of a great
technical diversity:
repoussé, niello, setting, etc.

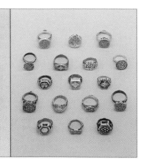

Page 106
Iran, Safavid period
Silver, copper, semi-
precious stones;
H. 25 mm
Roman recollections: the
shouldering of the middle
ring and of the one on
the far left; and
Byzantine: the motif of
facing birds.

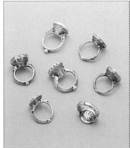

Page 107
Iran, Seljuq and Safavid
periods
Silver, niello; H. 29 mm
Illustration of various
calligraphies.

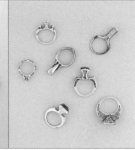

Page 108
Iran, Safavid period
Nielloed silver, partly gilt;
H. 36 mm
Even when seen from
the back, these rings are
of outstanding quality.
Shoulders with stylised
dragons and remains
of the fusing rod have
become ornamental.

Page 109
Iran, Seljuq and Safavid
periods
Silver, niello; H. 40 mm.

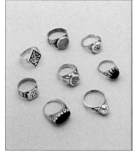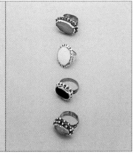

Page 110
Caucasus
Silver, niello, stone;
H. 31 mm.

Page 111
Central Asia (Turkoman)
Silver, cornelian, vitreous
paste and lapis-lazuli;
L. 34 mm
Throughout the Muslim
East, the blue stone is a
talisman against the evil
eye.

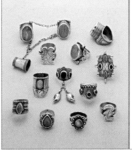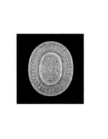

Page 112
Central Asia (Turkoman:
Tekke, Ersari, Yomud
lower left)
Silver, fire gilding,
cornelian; H. 46 mm
The horn motifs, big ring
on left and openwork
ring on right are stylised
ram horns.

Page 113
Central Asia (Kazakh)

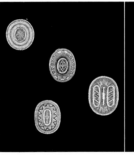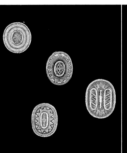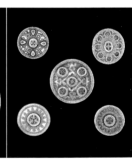

Pages 113-115
Central Asia (Kazakh)
Silver, fire-gilt, coloured
paper, glass; H. 83 mm,
D. 79 mm, H. 66 mm
False granulation. An
extremely rare figuration
of stylised camels and
horses on the ring at
upper left. For her
services, the matchmaker
receives from the bride's
mother, a *kudagi zhuzik*,
its double hoop referring
to the union.

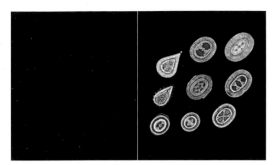

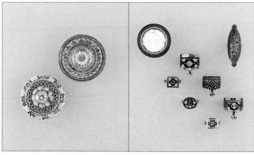

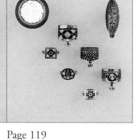

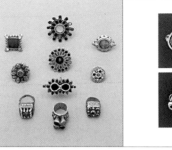

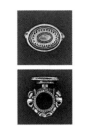

Page 117
Central Asia (Kazakh)
Silver, coloured paper, glass, bits of china from a teapot; H. 48 mm.

Page 118
Pakistan (Pashtun)
Silver, gilt silver, glass; D. 52 mm.

Page 119
Pakistan, Multan
Silver, cloisonné enamels, mirror; L. 40 mm
Blue enamel would be a substitute for lapis-lazuli reserved for important persons. The *shast*, diadem-shaped, and the ring with the mirror are worn on the thumb, the *patti*, the ellipse-shaped one, on the first finger.

Page 120
Afghanistan, Pakistan (Pashtun)
Silver, glass; D. 47 mm
Nomads' rings.

Page 121
India
Silver; H. 54 mm
Garuda, Vishnu's courser, represented as a bird of prey with a human body.

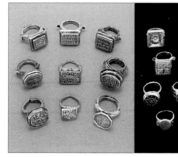

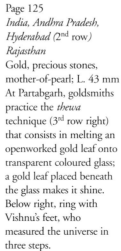

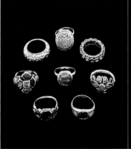

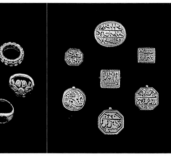

Page 122
India, Mogul period
Carved ivory; H. 41 mm
Archer's ring, worn on the thumb.

Page 123
India, Mogul period
Silver, incised stone; H. 45 mm
A ring that distils perfume (on left), calligraphy of an exceptional quality: Mogul refinement is in all things.

Page 124
India, Andhra Pradesh, Hyderabad
Silver; H. 38 mm
Muhr, men's chisel incised signet rings. The signet is especially useful in an illiterate society.

Page 125
India, Andhra Pradesh, Hyderabad (2nd row)
Rajasthan
Gold, precious stones, mother-of-pearl; L. 43 mm
At Partabgarh, goldsmiths practice the *thewa* technique (3rd row right) that consists in melting an openworked gold leaf onto transparent coloured glass; a gold leaf placed beneath the glass makes it shine. Below right, ring with Vishnu's feet, who measured the universe in three steps.

Page 126
India, Rajasthan and Maharashtra
Gold, precious stones; D. 27 mm
Most of these rings belong to the Mogul period.

Page 127
India, Andhra Pradesh, Hyderabad
Silver, gilt-edged; H. 36 mm
In India, sealing wax contained mostly lac, combined with wax, a pigment and sometimes perfume.

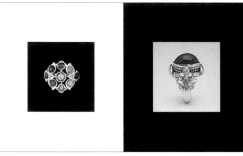

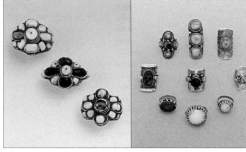
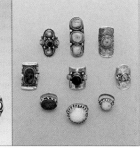
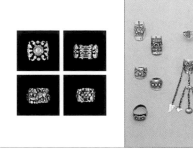

Page 152
Nepal
Gold, precious stones;
L. 27 mm
A wedding ring, the ring
with nine gems *nava
ratna* recalls the Indian
planetary system. The
floral motif is a variant of
the classic pattern
evoking the *mandala*.

Page 153
Tibet
Gold, coral; H. 30 mm
In Tibet, metals and
precious stones are
energy-giving; they are
believed to have curative
properties.

Page 154
Nepal
Silver, coral, turquoise;
L. 45 mm
These rings can also be
worn in the hair.

Page 155
Tibet
Silver, turquoise, coral;
H. 57 mm
Men and women
sometimes wear in their
hair saddle-rings.

Page 156
China
Silver; D. 25 mm
Fo dog, or lion holding a
ball—champion of the
law and protector of
sacred constructions—,
bat—symbol of joy and a
long life—,and flowers.

Page 157
China
Silver; H. 40 mm
Frog, associated with
water—the *yin* element—
, foliage, flowers and
peach. The small ring
with two flowers (lower
left) is a prostitute's ring.

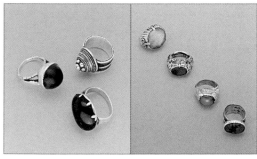
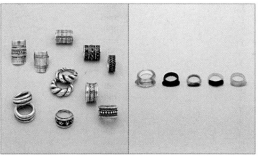

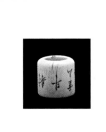
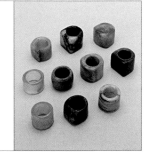

Pages 158-159
China, Kashgar
Silver, semi-precious
stones; H. 30 mm and
D. 31 mm
Rings of the Moslem
community.

Page 160
*China (Miao and Dong,
centre and below, Yao)*
Silver, cast, stamped,
filigreed and enamelled;
H. 33 mm
The *Dong* pair of twisted
rings is worn at the
wedding.

Page 161
China
Amber, died bone, jade
and glass; H. 30 mm
Amber prevents diseases
and pain.

Page 162
China
Carved ivory; D. 31 mm
Archer's ring.

Page 163
*China, Ming and Qing
periods*
Jade; H. 30 mm
By the Shang period,
archer's rings became
funerary; stable, jade was
supposed to prevent
bodily decomposition.

 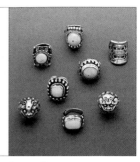 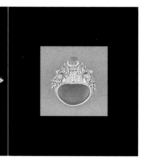 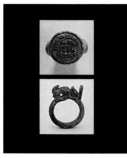 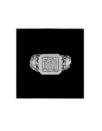

Page 164
Mongolia
Silver; D. 24 mm
Signet ring.

Page 165
Mongolia
Silver, coral, enamel;
H. 38 mm
The *Fo* dog on the left
has retractile eyes and
tongue.

Page 166
Burma (Pyu), from
excavations
Gold; L. 19 mm
The symbols are Hindu
and Buddhist. The crab is
an avatar of transcendent
life forces, the ram the
vehicle of the divinity
Kuvera, custodian of
treasures. The conch,
attribute of Vishnu, who
under the likeness of a
fish saved Manu, the

ancestor of the human
race, from the flood.

Page 167
Cambodia, Khmer period
Gold, rock crystal;
H. 29 mm
Repoussé Makala heads.

Page 168
Cambodia, Khmer period,
12th century
Bronze; H. 38 mm
Signet rings.

Page 169
Cambodia, 18th century
Gold; H. 21 mm
Signet ring.

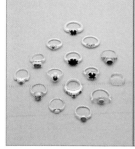 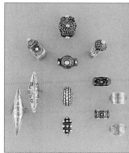 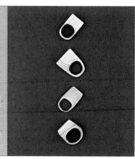 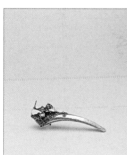 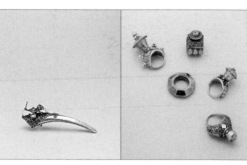

Page 170
Cambodia and Thailand,
Mon or Dvaravati and
Sukhothai periods
Gold, precious stones;
H. 32 mm
Between the 6th and the
15th centuries, rings are
highly structured, with a
noble severity.

Page 171
Thailand, Sukhothai,
Ayutthaya and ancient
Bangkok periods
Gold and precious stones;
H. 29 mm
Between the 15th and
18th centuries, rings are
more sophisticated,
techniques more
elaborate.

Page 172
Thailand (Akha, Meo
and Yao, on right*)*
Silver, enamel; H. 56 mm
The Akha sometimes
wear rings like those
above on their belt.

Page 173
Myanmar (Karen)
Carved ivory; H. 34 mm.

Page 174
Indonesia
Gold; L. 62 mm
Throughout South-East
Asia, the nail-protector is
a sign of wealth, long
nails preventing manual
work.

Page 175
Indonesia, Sumatra (Karo
Batak) and Sulawesi, the
octagonal ring
Silver and *suasa,* gold and
copper alloy; H. 61 mm
The ring at upper left
plays a role in *Adat*
ceremonies, it is a sign
of alliance.

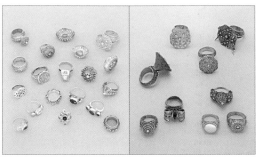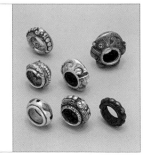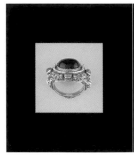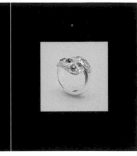

Page 176
Indonesia, Sumatra (Karo Batak above), Lampong, Minangkabau, Bali, Sumbawa, Sulawesi, Flores, Borneo
Gold, precious stones;
H. 37 mm
A great technical skill in the *repoussé*, filigree and granulation of the different islands of the archipelago. The ring in the centre is

decorated with the names of Allah and Mahomet.

Page 177
Indonesia, Sumatra (Karo Batak) and Sumbawa, the conic ring
Gilt silver; H. 40 mm
Octagonal rings, *cincin tapak gajah*, recall the elephant's footprint.

Page 178
Indonesia, Sulawesi (Toraja), Dongson period ?
Bronze; L. 43 mm
Recalls the *sanggori*, frontal snake-shaped ornament belonging to warriors or a stylised bird.

Page 179
Indonesia, Sumatra (Toba Batak)
Inlaid bronze, lost wax,
H. 50 mm
Men's rings, the *singa-naga* is a mythical creature part-elephant, part-snake, while *singa* means lion in sanskrit.

Page 180
Indonesia, Bali, Singaraja
Gold, sapphire and ruby, *repoussé*; L. 35 mm
Priest's thumb ring, whose special feature is its large size.

Page 181
Indonesia, Java, 18th century
Gold, diamonds;
H. 23 mm
Kraton (Royal Palace) ring, also attributed to islamised aristocracy.

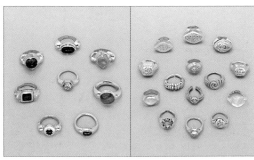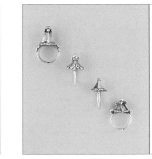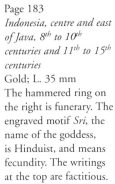

Page 182
Indonesia, centre of Java, 8th to 11th century
Gold and precious stones;
L. 28 mm
The stirrup shape and marked shoulder characterise rings of the high period.

Page 183
Indonesia, centre and east of Java, 8th to 10th centuries and 11th to 15th centuries
Gold; L. 35 mm
The hammered ring on the right is funerary. The engraved motif *Sri*, the name of the goddess, is Hinduist, and means fecundity. The writings at the top are factitious.

Page 185
Indonesia, Flores
Bronze; H. 50 mm
The ring below recalls women's earrings, important in matrimonial exchanges.

Page 186
Indonesia, Timor
Silver; H. 43 mm
Rings in the shape of an edifice.

Page 187
Indonesia, Nusa Penida
Silver. D. 25 mm
The spiral represents the repeated rhythms of life. It is a symbol of fecundity.

America

Page 188
United States (Zuni)
Silver, mother-of-pearl
and jet; H. 36 mm.

Page 191
Guatemala
Silver, bits of glass;
H. 28 mm
The skeleton is the
personification of death.
Birds' flight makes them
tend to be used as a
metaphor for the
connection between
heaven and earth. Joined
hands mean a promise.

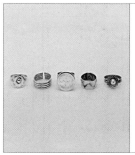

Page 192
Chile (Araucan)
Silver; D. 22 mm
Mapuche rings are very
scarce.

Page 193
United States (Navajo)
Silver, turquoise;
H. 40 mm
The aesthetic choices of
the Navajo tend to
simplicity.

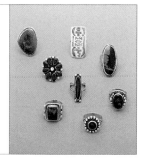

Page 194
*Canada, Hudson Bay, 18th
century*
Silver; H. 22 mm.

Page 195
*Unites States (Navajo),
1920-1930*
Silver, turquoise and
fossil wood at upper
right; H. 36 mm
The plainest rings are the
oldest.

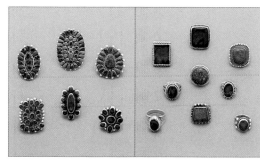

Page 196
*United States (Zuni and
Navajo)*
Silver, turquoise;
H. 48 mm
The Zuni were fond of
turquoise "mosaics".

Page 197
United States (Navajo)
Silver, turquoise;
H. 31 mm
The Indians set great
store by the provenance
and quality of turquoises.

Appendix

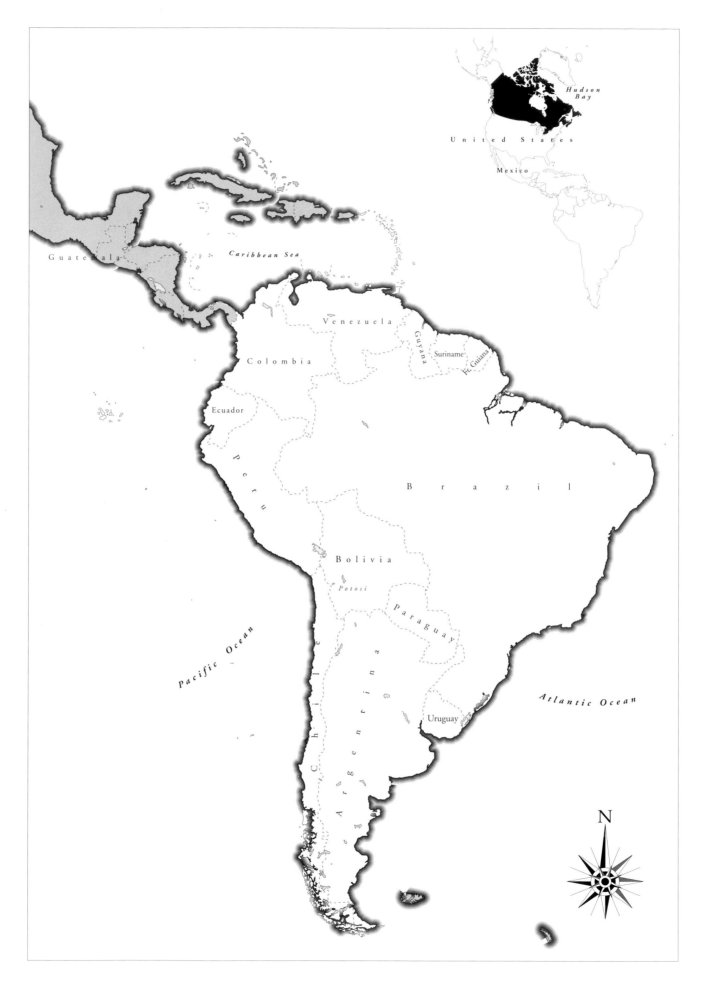

Guatemala

Caribbean Sea

Venezuela

Colombia

Guyana

Suriname

Fr. Guiana

Ecuador

Peru

Brazil

Bolivia

Potosi

Paraguay

Pacific Ocean

Chile

Argentina

Uruguay

Atlantic Ocean

N

United States

Hudson Bay

Mexico

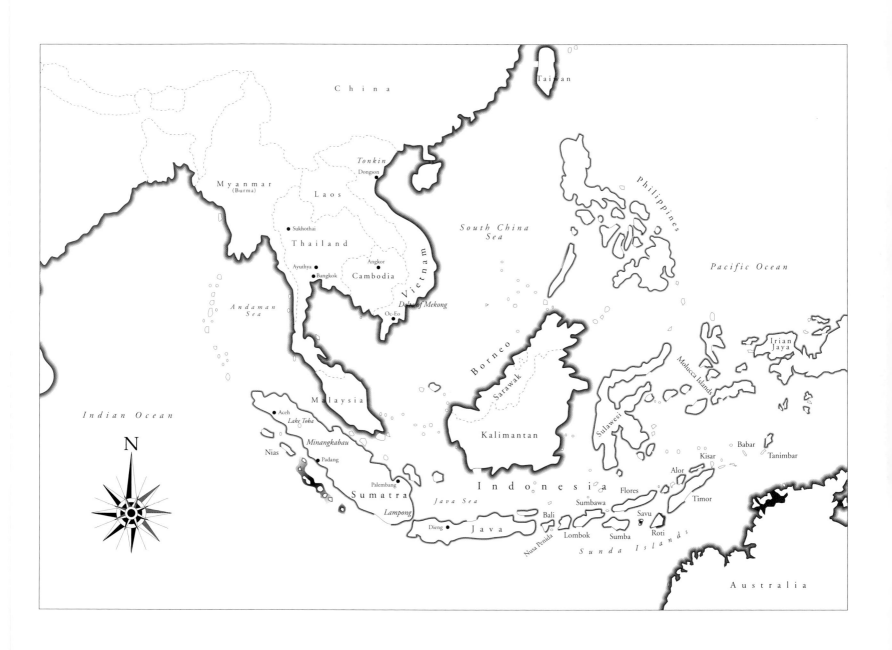

less thick leaf, which then will be shaped by various processes.

Lost wax
Can be solid, or hollow if it has a central core in refractory material. The fused metal takes the place of the wax model, in a cooking die destroyed after the casting, once the object is cooled. With the destruction of the original model the *lost wax* produces a one-off.

Niello
Inlaid decoration of a blackish material into lines cut away from a light-coloured metal. Niello has a base of metal sulphides.

Openwork
Motif cut out in a metal leaf.

Pyrography
Application of a decoration onto ivory, bone or wood with a red-hot tool.

Repoussé (Punching)
Relief decoration technique of a metal leaf. The metalworker punches the metal from behind to make the forms emerge; the work is often completed by chiselling on the right side.

Ring
Jewel worn on the finger composed of a hoop, a bezel, that is the raised decorative part, and shoulders or portions of the hoop fastening the setting to each side.

Sand casting
the models are hard materials moulded in refractory sand, pressed into a frame. It allows to make several copies of the same model.

Setting
Assembling and mounting of stones or other materials in a metal setting.

Silver
Precious metal that is found as ore or combined, in minerals, with other metals such as gold, lead, copper or zinc. It is very ductile and malleable. Sterling silver is composed of 925‰ silver and 75‰ copper.

Silver-plating
Layer of silver applied onto a metal object.

Soldering
Assembling whereby pieces of metal are stuck together by direct heating in fire or by blow-torch. It is performed with or without a fusible alloy, solder.

Stamping
Relief shaping and decorating of a metal leaf from a stamp, the die allowing the execution of countless copies. The die, usually bronze or steel, is hollowed in the shape and with the decoration to be obtained. This is performed by hammering the metal leaf into the die. Like for *repoussé*, the metal is stamped on the back, so as to obtain precise and clear relief forms on the front.

Wash gilding (or fire gilding)
Gilding using the amalgam of gold and mercury. Once the amalgam is applied and heated, the mercury volatilises and the gold spreads, covering the surface to be gilt.

Wet gilding (or soaked gilding)
Gilding by the immersion of small silver, copper or brass objects, based on the principle of the precipiting of metals and their dissolving by other, more oxidisable metals.

Wire
The shaping of metal in wires is obtained by hammering or stretching (wiredrawing) in a drawplate. The wires have various sections, dimensions and calibres, decorated or not, and are assembled in different ways to form or adorn objects.

For the glossary, many definitions have been taken from L'Art du Métal, *by C. Arminyon and M. Bilimoff, Editions du Patrimoine, Paris, 1988.*

Index

LIBRARY
D.I.T. MOUNTJOY SQ.

225

Bibliography

LIBRARY
D.I.T. MOUNTJOY SQ.

General

Arminjon C., Bilimoff M., *L'Art du Métal*, Editions du Patrimoine, Paris, 1988.

Borel F., *The Splendor of Ethnic Jewelry*, Harry N. Abrams, New York, 1984. French Transl., *Orfèvres lointains. Bijoux d'Afrique, d'Asie, d'Océanie et d'Amérique*, Hazan, Paris, 1995. Italian Transl., *Ethnos. Gioielli da terre lontane*, Skira, Milano, 1996. German Transl., *Schmuck, Kostbarkeiten aus Afrika. Asien. Ozeanien und Amerika*, Hatje Cantz Verlag, Ostfildern-Ruit, 1999.

Chevalier J., Gheerbrant A., *Dictionnaire des Symboles*, Robert Laffont / Jupiter, Paris, 1982.

Collectif sous la direction de Cerval M.de, *Dictionnaire international du Bijou*, Regard, Paris, 1982.

Content D.J. (ed.), *Islamic Rings and Gems, the Zucker Collection*, Ph. Wilson Publishers Ltd, London, 1987.

Dubin L.S., *The History of Beads from 30.000 B.C. to the Present*, Harry N. Abrams, New York, 1987. Italian Transl., *La storia delle perline*, Garzanti, Milano, 1988. French Transl., *Histoire des Perles*, Nathan, Paris, 1988.

Hasson R., *Early Islamic Jewelry* and *Later Islamic Jewelry*, L.A. Mayer Institute for Islamic Art, 2 vol., Jerusalem, 1987.

Jenkins M., Keene M., *Islamic Jewelry in the Metropolitan Museum of Art*, The Metropolitan Museum of Art, New York, 1982.

Klever K. und U., *Exotischer Schmuck*, Mosaik, München, 1977.

Mack J. (ed.), *Ethnic Jewelry*, Harry N. Abrams, New York, 1988.

Spink M. (ed.), *Islamic and Hindu Jewellery*, Spink and Son, London, 1988.

Spink M. (ed.), *Islamic Jewellery*, Spink and Son, London, 1986.

Spink M. (ed.), *Islamic Jewellery*, Spink and Son, London, 1996.

Tait H. (ed.), *Jewellery through 7000 years*, British Museum Publications Ltd, London, 1976.

Africa

Bachinger R., Schienerl P.W., *Silberschmuck aus Ägypten*, Galerie Exler & Co., Frankfurt am Main, 1984.

Balandier G., Maquet J., *Dictionnaire des Civilisations africaines*, Hazan, Paris, 1968.

Beckwith C., Fisher A., *African Ark*, Collins Harvill, London, 1990.

Besancenot J., *Bijoux berbères du Maroc*, Galerie de l'orfèvrerie Christofle, Paris, 1947.

Blandin A., *Afrique de l'Ouest, Bronzes et Autres Alliages*, Blandin, Marignane, 1988.

Camps-Fabrer H., *Bijoux berbères d'Algérie*, Edisud, Aix-en-Provence, 1990.

Creyaufmüller W., *Silberschmuck aus der Sahara, Tuareg und Mauren*, Galerie Exler & Co., Frankfurt am Main, 1982.

Creyaufmüller W., *Völker der Sahara, Mauren und Tuareg*, Linden-Museum, Stuttgart, 1979.

Eudel P., *Dictionnaire des bijoux de l'Afrique du Nord*, Ernest Leroux, Paris, 1906.

Falgayrettes-Leveau C., *Corps sublimes*, Musée Dapper, Paris, 1994.

Fisher A., *Africa adorned*, Collins, London, 1984. French Transl., *Fastueuse Afrique*, Ed. Du Chêne, Paris, 1984. Italian Transl., *Gioielli africani*, Rusconi Immagini, Milano, 1984. German Transl., *Afrika im Schmuck*, Du Mont, Köln, 1987.

Gabus J., *Oualata et Gueïmaré des Nemadi, Rapport brut des missions ethnographiques en R.I. de Mauritanie, du 19 décembre 1975 au 29 mai 1976*, Musée d'Ethnographie, Neuchâtel.

Gabus J., *Sahara. Bijoux et Techniques*, A la Baconnière, Neuchâtel, 1982.

Garrard T., *Gold of Africa: Jewellery and Ornaments from Ghana, Côte d'Ivoire, Mali and Senegal in the collection of the Barbier-Müller Museum*, Munich, Prestel et Genève, Musée Barbier-Müller, 1989. French Transl., *Or d'Afrique. Bijoux et Parures du Ghana, Côte d'Ivoire, Mali et Sénégal de la collection Barbier-Mueller*, Hazan, Paris, 1990, German Transl., *Afrikanisches Gold: Schmuck, Insignen und Amulette aus Ghana, Mali, dem Senegal und von der Elfenbeinküste*, Prestel, München, 1989.

Göttler G., *Die Tuareg, Kulturelle Einheit und regionale Vielfalt eines Hirtenvolkes*, DuMont Buchverlag, Köln, 1989.

Grammer I., De Meersman M. (ed.), *Splendeurs du Maroc*, Musée royal de l'Afrique centrale, Tervuren, 1998.

Holas B., *Animaux dans l'art ivoirien*, Librairie Orientaliste Paul Geuthner S.A., Paris, 1969.

Kalter J., *Schmuck aus Nordafrika*, Linden-Museum, Stuttgart, 1976.

Kolb E. de, *Soothsayer Bronzes of the Senufo*, Galerie d'Hautbarr, New York, 1968.

Leopoldo B., *Egypte. Oasis d'Amun-Siwa*, Musée d'Ethnographie, Genève, 1986.

Meyer L., *Les Arts des métaux en Afrique noire*, Sépia, Saint-Maur, 1997.

Rabaté J. et M.-R., *Bijoux du Maroc, du Haut-Atlas à la vallée du Draa*, Edisud, Le Fennec, 1996.

Rouach D., *Bijoux berbères au Maroc dans la tradition judéoarabe*, ACR Ed., Paris, 1989.

Sieber R., *African Textiles and Decorative Arts*, Museum of Modern Art, New York, 1972.

Spring C., *African Arms and Armour*, British Museum, London, 1993.

Utotombo. L'Art d'Afrique noire dans les collections privées belges, Palais des Beaux-Arts, Société des Expositions, Bruxelles, 1988.

Vanderhaeghe K., *Les bijoux ethiopiens, ornements ou symboles?*, in "Aethiopia. Peuples d'Ethiopie", Cultures & Communications, Gordon & Brenel Arts International, 1996, pp. 326 ss.

Asia

Asian Art Museum of San Francisco (ed.), *Beauty, Wealth and Power: Jewels and Ornaments of Asia*, San Francisco, 1992.

Boyer M., *Mongol Jewellery*, Nationalmuseet Skrifter, etnografisk roekke, Copenhague, 1952. New edition: *Mongol Jewelry*, Thames and Hudson, London, 1995.

Campbell M., *From the Hands of the Hills*, Media Transasia, Hongkong, 1978.

Cohen Grossman G. (ed.), *The Jews*

229

of Yemen. An exhibition organized by the Maurice Spertus Museum of judaica, Spertus College of Judaica Press, Chicago, 1976.

Dupaigne B., *Le grand art décoratif des Turkmènes*, dans "Objets et mondes", vol. XVIII, Bd. 2, Paris, 1978.

Hawley R., *Omani Silver*, Longman, London / New York, 1978.

Hendley T.H., *Indian Jewellery (1909)*, Cultural Publishing House, Delhi, 1984.

Hendley T.H., *Indian Jewellery*, dans "The Journal of Indian Art and industry", XII, July 1909.

Höpfner G., Haase G., *Metallschmuck aus Indien*, Museum für Völkerkunde, Berlin, 1978.

Hoskin Y., *A Buyer's Guide to Thai Gems and Jewellery*, Asia Books, Bangkok, 1988.

Janata A., *Schmuck in Afghanistan*, Akademische Druck- und Verlagsanstalt, Graz, 1981.

Jasper J.E., Pirngadie M., *De Inlandsche Kunstnijverheid in Nederlandsch Indië*, Deel IV, De goud-en zilversmeedkunst, De Boeck & Kunstdrukkerij v/h Mouton & Co., s'Gravenhage, 1927.

Kalter J., *Aus Steppe und Oase. Bilder turkestanischer Kulturen*, Ed. Mayer, Stuttgart, 1983.

Latif M., *Bijoux moghols*, Société Générale de Banque, Bruxelles, 1982.

Latif M., in *Een streling voor het oog. Indische Mogoljuwelen van de 18de en de 19de eeuw*. Tr. angl., *A Kaleidoscope of colors. Indian Mughal Jewels from the 18th and 19th Centuries*, Provinciaal Diamant Museum, Antwerpen, 1997.

Lewis P. et E., *Peoples of the Golden Triangle: Six Tribes in Thailand*, Thames and Hudson, London, 1984.

Mare C. Del, Vidale M., *Le Vie del Corallo. Secondo Itinerario. Il corallo nel gioiello etnico indiano*, Banca di Credito Popolare, Electa, Napoli, 1999.

Mare C. Del, Zolla E., *Le Vie del Corallo. Il corallo nella gioielleria etnica della Mongolia*, Banca di Credito Popolare, Electa, Napoli, 1997.

Miksic J.N., *Old Javanese Gold*, Ideation, Singapur, 1990.

Miksic J.N., *Small Finds: Ancient Javanese Gold*, The National Museum, Southeast Asian Gallery, Singapur, 1988.

Montigny A., *Alliages et Alliances des armes et des bijoux d'Oman*, Institut du Monde Arabe, Paris, 1989.

Moor M. de, Kal W.K., *Indonesische sieraden*, Het Tropenmuseum, Amsterdam, 1983.

Morris M., Shelton P., *Oman Adorned. A Portrait in Silver*, Apex Publishing, Muscat & London, 1997.

Muchawsky-Schnapper E., *The Jews of Yemen. Highlights of the Israel Museum Collection*, Jerusalem, 1994.

Munneke R., *Van Zilver. Goud en Kornalijn*, Rijksmuseum voor Volkenkunde, Leiden / Breda, 1990.

National Palace Museum (ed.), *Catalogue of the Exhibition of Ch'ing dynasty costume accessories*, Taipeh, 1986.

Pressmar E., *Indische Ringe*, Insel-Verlag, Frankfurt am Main, 1982. English transl., *Indian Rings*,

Insel-Verlag, Frankfurt am Main, 1982.

Rajad J.S., *Silver Jewellery of Oman*, Tareq Rajab Museum, Kuwait, 1977.

Rodgers S., *Power and Gold: Jewelry from Indonesia, Malaysia and the Philippines, from the collection of the Barbier-Müller Museum Geneva*, Prestel, München, 1988. French transl. *L'or del îles. Bijoux et ornements d'Indonésie, de Malaisie, et des Philippines dans les Collections du Musée Barbier-Mueller*, Genève, 1991.

Ross H.C., *Bedouin Jewellery in Saudi Arabia*, Stacey International, London, 1978.

Ross H.C., *The Art of Bedouin Jewellery. A Saudi Arabian Profile*, Arabesque Commercial, Fribourg, 1981.

Rudolph H., *Der Turkmenenschmuck, Sammlung Kurt Gull*, Ed. Mayer, Stuttgart, 1984.

Schletzer D. et R., *Alter Schmuck der Turkmenen*, Reimer, Berlin, 1983. English transl., *Old Silver Jewellery of the Turkoman*, Reimer, Berlin, 1984.

Srisavasdi B.C., *The Hill Tribes of Siam*, Odeon Store, Bangkok, 1966.

Stronge S., Smith N., Harle J.C., *A Golden Treasury. Jewellery from the Indian Subcontinent*, Victoria and Albert Museum and Mapin Publishing, London, 1988.

Sychova N., *Traditional Jewellery from Soviet Central Asia and Kazakhstan*, Sovetsky Khudozhnik, Moscou, 1984.

The Newark Museum, *Catalogue of the Tibetan collection and other Lamaist Articles*, vol. V, Newark, New Jersey, 1950.

Untracht O., *Traditional Jewelry of India*, Thames and Hudson Ltd., London, 1997.

Wassing-Visser R., *Sieraden en lichaamsversiering uit Indonesië*, Volkenkundig Museum Nusantara, Delft, 1984.

Weihreter H., *Schmuck aus dem Himalaya*, Akad. Druck- und Verlagsanstalt, Graz, 1988.

Windisch-Graetz S. et G., *Trésors de l'Himalaya*, La Bibliothèque des arts, Lausanne / Paris, 1982.

Xianyang Zeng, *Mœurs et Coutumes des Miao*, 24, Bai Wan Zhuang, Beijing, 1988.

America

Bedinger M., *Indian Silver. Navajo and Pueblo Jewelers*, University of New Mexico press, Albuquerque, 1973.

Hartmann G., *Silberschmuck der Araukaner, Chile*, Museum für Völkerkunde, Berlin, 1974.

Jacka J.D., Hammack N.S., *Indian Jewelry of the Prehistoric Southwest*, The University of Arizona Press, Tucson, 1975.

Lincoln L. (ed), *Southwest Indian Silver from the Doneghy Collection*, University of Texas, The Minneapolis Institute of the Arts, Austin 1982.

Mera H.P., *Indian Silverwork of the Southwest illustrated*, vol. I, Dale Stuart King, Tucson, 1977.

Rosnek C., Stacey J., *Skystone and Silver*, Prentice Hall, Englewood Cliffs, N.J., 1976.

Woodward A., *Navajo Silver*, Northland Press, Flagstaff, 1971.

LIBRARY
D.I.T. MOUNTJOY SQ.